IMAGES
of America

CIRCLE Z
GUEST RANCH

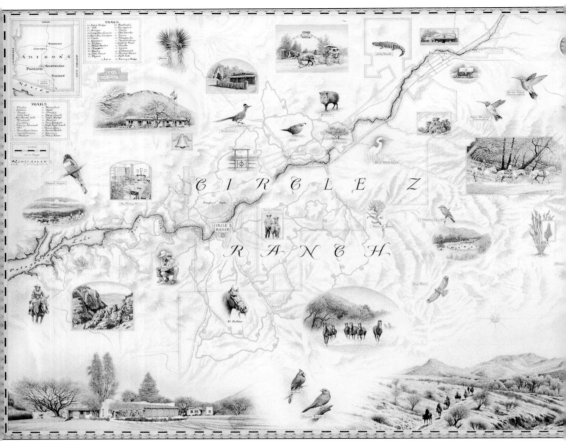

MAP OF CIRCLE Z. The Circle Z Guest Ranch is situated in the rugged countryside of southeastern Arizona, seven miles from Patagonia and 60 miles south of Tucson. Since 1976, the present owner, Lucia Nash, and her family have operated the Circle Z as a winter guest ranch and cattle ranching operation. Current landholdings comprise 6,500 acres of deeded land. This unique map, hand-drawn by artist Chris Robitaille, illustrates the ranch complex today. (Courtesy of Diana Nash.)

ON THE COVER: SONOITA CREEK TRAIL RIDE. In 1950, Fred Fendig decided to take a needed vacation from his executive position at a Chicago bank to experience first-hand the Old West and its ranching traditions at the Circle Z Guest Ranch. Six months later, the 39-year-old banker was the owner and manager of one of the finest, most popular guest ranches in Arizona. Fendig (first row, far left), wrangler John Cameron (first row, far right), Cheryl Allen (second row, second from right) and Isabel Allen (far right), and guests are shown here splashing through the ever-flowing Sonoita Creek under the shade of the giant cottonwoods. (Courtesy of Ray Manley Photography.)

IMAGES
of America

CIRCLE Z
GUEST RANCH

Gail Waechter Corkill

ARCADIA
PUBLISHING

Published by Arcadia Publishing
Charleston, South Carolina

Printed in the United States of America

Library of Congress Control Number: 2015955947

For all general information, please contact Arcadia Publishing:
Telephone 843-853-2070
Fax 843-853-0044
E-mail sales@arcadiapublishing.com
For customer service and orders:
Toll-Free 1-888-313-2665

Visit us on the Internet at www.arcadiapublishing.com

To my husband, Eldon Lee Corkill, my love for you is like a red, red rose.

CONTENTS

FOREWORD

I first heard of the Circle Z Ranch during my engagement to be married to Rick Nash in the winter of 1993. Visiting with his mother, Lucia, at her home in Ohio, our conversation was dominated with detailed stories of her childhood days spent roaming the hills of Arizona with her family and how she came to be the owner of the ranch. As I listened to this fairy-tale story, I wondered, "Could there really be such a place, so peaceful and beautiful, with horses to boot?" As a child, I loved horses and dreamed of being a cowgirl on a ranch.

So here Rick and I are today, many years later, with our own stories to share of the phenomenal Circle Z Ranch. We have come to know hundreds of fascinating people from around the world who converge on this magical place with their common interests of horses, nature, and serenity. We have learned the gifts of the desert, as small and fleeting as they may be and as important and timeless as they are. Sharing the beloved Circle Z Ranch with others and helping to protect and preserve its timelessness is more than we ever dreamed possible. We are blessed every day to be able to help carry on our traditions in sharing the gifts of the Southwest desert with our guests, as Lucia did all her life. And I am living my dream of being a cowgirl on a ranch.

We thank Gail Waechter Corkill for her help in bringing our stories to life and giving us this opportunity to share with the world what the Circle Z Ranch has meant to thousands of guests spanning decades of time. With her encouragement and energy, our photographs and stories have been dusted off and brought into the light.

—Rick and Diana Nash

ACKNOWLEDGMENTS

It was a true privilege to write about such a treasured place, an opportunity that would not have been possible without the support of Rick and Diana Nash. I was inspired by the Nash family's love of Circle Z and fervor to keep its legacy alive.

I am forever grateful to Diana Nash for her encouragement and diligence throughout this challenging project.

I am also grateful to Sarah Gottlieb, my title manager, for her invaluable assistance, optimism, and countless words of encouragement.

I wish to thank Bill Bergier, Bob Bergier, Gilbert Quiroga, Carolyn Robinson, and The Patagonia Museum for kindheartedly granting me permission to publish their photographs. Thanks to all who generously shared their memories of Circle Z, namely Bill Bergier, Bob Bergier, Bailey and Susie Foster, Maude Foster, George and Jennie Lorta, Alejandro "Cano" Quiroga, Margaret Whelan Salge, Dick Schorr, Rosalia "Sissy" Salge Stephenson, and Doris Simmons. I am also thankful to Jackie Rothenberg and Joe Balden for their friendship and counsel.

I extend my sincere appreciation to German Quiroga of The Patagonia Museum for loaning resources and assisting me in the research of this book. Thanks to Christine Auerbach, Gail Balden, Joe Balden, Diana Nash, Roy Richard, Chris Roelke, Jackie Rothenberg, and Deni Seymour for editing assistance.

The content of this book is based on the many newspaper clippings, magazine articles, brochures, guest registers, journals, personal correspondence, and postcards that Lucia Nash preserved in storage bins discovered in the basement of the ranch main lodge, as well as oral histories and the stories of those who lived and worked on the Circle Z Guest Ranch. This collection spans a period of eight decades. The images in the book are courtesy of the Nash family, Ray Manley Photography, the Bergier family, Gilbert Quiroga, and StevensonPhotography.com.

INTRODUCTION

The Circle "Z" Ranch of today still includes all the principal attractions of the old Sanford Ranch. There still exists the same beautiful country and the same wonderful weather. A thrilling history, a picturesque scenery and a clement climate; a truly delightful place.

—Lee G. Zinsmeister, 1929

At a time in the early days of southeastern Arizona when Apache incursions and cattle rustling were constant threats, brothers Denton Gregory Sanford and Don Alonzo Sanford of New York decided to head west to make their fortune. In 1874, Denton G. Sanford settled in territorial Arizona intending to raise cattle. His homestead was situated at an altitude of 4,000 feet in the picturesque Patagonia and Santa Rita Mountains. The dwelling he purchased was on a mesa overlooking Sonoita Creek. Sanford's spacious, four-room adobe house with three additional buildings was considered the finest *hacienda* (the house of an owner of a large estate) in the territory. Denton Stanford homesteaded on the San Jose de Sonoita Land Grant, given to Don Leon Herreras by Mexico before the Gadsden Purchase of 1854. Sanford was unaware that homesteading on Mexican land grants was exempt under the provisions of the land acquisition treaty between the United States and Mexico.

In 1873, Don A. Sanford met Louisa Jane Bloxton of Pennsylvania while on a business trip in Washington, DC. They corresponded for two years while Don established the Stockton Valley Ranch in the Sonoita area about 17 miles northwest of Denton's hacienda. In 1875, Louisa and her brother Benjamin Bloxton arrived in Tucson to place a claim on additional land a few miles from the Denton Sanford ranch. She lived there until she married Don Sanford in Tucson on October 5, 1875. The Sanfords raised barley and beef to sell to the army outposts of Camp Crittenden and Camp Huachuca. In 1881, Don Sanford closed out his herd of cattle for 13,000 head of sheep owned by Tully, Ochoa & Delong of Tucson. The profitable Sanford sheepherding operation ran until 1884. Denton Sanford died on January 22, 1885.

In the 1880s, Don Sanford sold Stock Valley Ranch and his "DS" brand to prominent cattle rancher Walter L. Vail of Empire Ranch on the east slope of the Santa Rita Mountains along Cienega Creek. The Sanford family moved to Denton Sanford's Aztec Ranch/97 Ranch. For many years, they lived there with their children, Etta, Amo, Mable, Bertha, and Don Jr. The Sanfords moved to Washington, DC, in 1886 to claim ownership of Denton Sanford's ranch estate for the Sanford family. Don Sanford continued to operate his businesses in Arizona with frequent visits to Tucson and southeastern Arizona. In 1912, Sanford v. Ainsa was argued before the US Supreme Court. Sanford lost most of his brother's land holdings to the successors of Don Leon Herreras. After 30 years of legal battles, Sanford obtained a deed to a very small fraction of the land his brother Denton had claimed. Pioneer Don Sanford died on May 15, 1915, in Washington, DC.

The story of Circle Z Guest Ranch as it is today spans 90 years, beginning when wholesale grocery businessman and internationally known coffee expert Lee G. Zinsmeister arrived in Tucson in 1924. Tucson was where his brother Carl F. Zinsmeister lived with his wife, Nadine, and daughter, Joanne. Lee Zinsmeister fell in love with Arizona. The Zinsmeister brothers' shared vision was to operate a working cattle ranch that sidelined as a semi-resort guest ranch. They were the first in the industry to use the term "guest ranch" instead of "dude ranch." In 1925, Carl and Lee established the Zinsmeister Ranch Company. After a five-month search, they purchased 5,000 acres of pristine land from V.D. Ely, the descendent of the rightful owner of the San Jose de Sonoita land grant. In addition, Bertha Sanford Miller, the Sanfords' youngest daughter, sold what remained of the old Sanford Ranch to the Zinsmeister family. The acreage and the old Sanford Ranch encompassed the Zinsmeisters' Circle Z Guest Ranch. Within the year, Lee, Carl, and Nadine Zinsmeister broke ground across the creek from the ruins of the old Sanford Ranch House.

The written history of the Circle Z Ranch dates to the late 1600s, when Fr. Eusebio Francisco Kino began pushing northward into the Upper Santa Cruz River Valley. He was seeking new locations to build *visitas* (Spanish visiting station, church, or settlement on the circuit of a priest or missionary). In a pass between the Santa Rita and Patagonia Mountains, he discovered a thriving Sobaípuris (Sobajípuris) settlement on a high mesa overlooking Sonoita Creek called Sonoitac. Sheridan indicated that there were three groups of Sobaípuris people. The first lived down San Pedro River north of Fairbank. Another lived on the Santa Cruz River between San Xavier del Bac and Picacho. The third lived on the Gila River west of Casa Grande. Kino had established Sonoitac as a visita of Guevavi, the head mission north of Tumacácori. He renamed Sonoitac "Los Santos Reyes de Sonoidag." Some believe the settlement was located where the Circle Z Ranch now stands. By 1821, Sonoidag had been abandoned for 50 years. Many remnants of an extensive Indian and Spanish settlement were discovered on the Circle Z property. Petroglyphs can be found on the rocks of a hill along Sonoita Creek. Artifacts of pottery shards, grinding stones, implements, and weapons were found in the area as well. A mile northeast of the old Sanford Ranch was the John Ward Ranch. Ward's foster son, Felix Ward (also known as Mikey Free), was kidnapped by a Western Apache band. Mistakenly thinking Cochise's Chiricahua band had taken the young boy, Capt. George Bascom's pursuit of Cochise to rescue Felix Ward instigated the famous Bascom Affair in 1861. This was the critical event that triggered the Apache War between the United States and the many tribes in Arizona and New Mexico.

In 1920, the population of Patagonia was 757 people, 58 percent Hispanic and 42 percent Anglo. The drop in cattle and ore prices coupled with the declining revenues of the railroad created economic uncertainty for the small frontier town. In 1924, Carl and Lee Zinsmeister brought a new tourism industry to the community. They helped the local economy by building, in addition to the adobe main house, individual cottages and furnishings on the ranch complex. The Zinsmeisters' Circle Z Guest Ranch was Patagonia's first dude ranch, located five miles southwest of town. Circle Z opened for the winter season of 1926 with a capacity of 24 guests. This was the height of the golden age of dude ranching and the tourism boom in Arizona. The magazine *Arizona Highways* was fast becoming Arizona's and Circle Z's major promoter of tourism. Guests arrived by way of the Southern Pacific Railroad and New Mexico & Arizona Railroad or by automobile. Circle Z Ranch, a working cattle ranch, was also a member of the Dude Ranchers' Association, founded in 1926, as it is today.

In 1928, Lee G. Zinsmeister married Helen T. Keller of Los Angeles. Carl and Nadine Zinsmeister left Circle Z and sold all their interest to the newlyweds. Lee and Helen Zinsmeister were the sole resident owners. The couple made extensive improvements and additions to ranch headquarters. They were marvelous hosts who welcomed guests to their family-style ranch with its beautiful scenery. The ideal climate was perfect for horseback riding in the high country and relaxing in the sun. On average, guests stayed for one month, and some families remained for the entire season. Guests who traveled by train stored their private railway cars on a siding by the Patagonia train station. Circle Z horses and experienced wranglers were the outstanding pleasure for their guests.

The guests could also play polo, swim, or participate in local ranch rodeos, roundups, and other Patagonia events. Guests could always expect excellent accommodations with all the comforts of home, fine dining, wholesome food, and personable staff. Lee and Helen hosted the annual Fourth of July Patagonia Barbecue and Rodeo at Circle Z. By 1929, this event was the largest attraction in Santa Cruz County, with up to 2,000 people in attendance.

With the stock market crash in 1929 and the abandonment of the railroad line connecting the town to Mexico, the local economy did not see improvement until 1938, when the American Smelting and Refining Company trench-flux mill and power plant came to the area. During this time, the ranch became a well-known vacation spot for tourists from around the world. This was a special place for the many guests who returned year after year and for the locals who worked there. Circle Z became the home of El Sultan, the famous Spanish Carthusian stallion. El Sultan entertained guests with his riding tricks and sired many colts, establishing the Circle Z breed of horses.

With the onset of World War II, the tourism industry experienced a slowdown, and Lee and Helen Zinsmeister began hosting some business groups at Circle Z. Lee Zinsmeister's health declined, and they sold the ranch in 1946 to Douglas Robinson of Tucson. Lee and Helen purchased the Lucky Hills Ranch, a cattle ranch near Tombstone, as their new home. Circle Z changed hands several times over the next four years. Patagonia officially incorporated on February 10, 1948. That same year, Edward Westrup and Helen Bessler of Chicago purchased the ranch. The following year, Charles Wheaton and Isabel Allen of Chicago became the next owners of Circle Z Guest Ranch.

Chicagoan Fred Fendig visited the ranch in the spring of 1950. Six months later, he purchased the Allens' interest. During the 1950s, Patagonians worked together to market the town as a viable tourist destination for people who were lured by the American West and the charm of their authentic Western town. Patagonia and the Circle Z became the hot spots for dudes from around the world and a venue for the film industry. Many Hollywood movies and television episodes were shot on location at and around the ranch, most notably *Broken Lance*, *Monte Walsh*, and *Gunsmoke*. Patagonia was featured in *Arizona Highways*, and many Ray Manley photographs of Circle Z were featured in the magazine. Patagonia Lake was created in 1968, when Sonoita Creek was dammed several miles south of the ranch. The following year, the Nature Conservancy purchased 312 acres of nesting area by the creek, creating the Patagonia–Sonoita Creek Preserve.

For the next 25 years, Fred Fendig was the managing owner of Circle Z, until he retired in 1974. When Preston and Lucia Nash Jr. of Ohio heard rumors that the ranch might be sold to a land development corporation or become a tennis ranch, they were determined to purchase it with the help of their family. They did so the following year. Their aim was to operate Circle Z Guest Ranch in keeping with the honored traditions established by pioneers Lee and Helen Zinsmeister. Lucia and Preston and their children dedicated themselves to making every effort to run a welcoming, old Western family-style ranch, with an emphasis on informality, relaxation, and comfortable accommodations. Good home-style cooking and horseback riding in the colorful countryside, with its varied terrain and hundreds of miles of trails, are delights for guests to this day.

The remarkable history of the Circle Z Guest Ranch is told through the stories and cherished memories of the people who lived at, worked on, and vacationed at this special place over the past 90 years.

One

A NEW VISION FOR A
FRONTIER TOWN

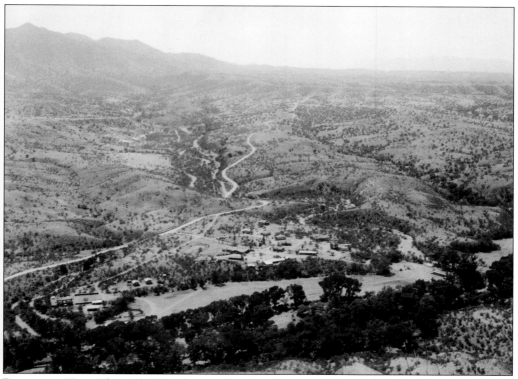

PANORAMIC VIEW. This mid-1920s photograph, taken from atop the Sanford Butte, shows a panoramic view of the Circle Z Ranch. Ranch headquarters can be seen on the plateau overlooking the polo and rodeo field directly above the ribbon of Fremont cottonwoods, sycamores, and hackberries along Sonoita Creek (foreground). The Patagonia-Nogales Highway is seen in the distance against the backdrop of the Patagonia Mountains to the east. (Courtesy of the Nash family.)

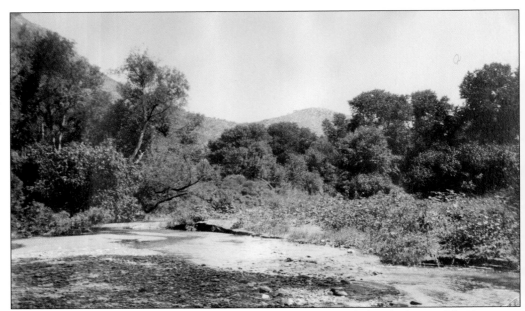

SONOITA CREEK. In the 1870s, Denton Gregory Sanford homesteaded in the heart of the Patagonia and Santa Rita Mountains at a scenic spot that overlooks Sonoita Creek. The beautiful Sonoita Creek, which traverses the property, is one of the few streams in Arizona to flow year-round. Sanford purchased a spacious, four-room adobe house built in 1874. This is a view of the creek where the Sanford homestead once stood. (Courtesy of the Nash family.)

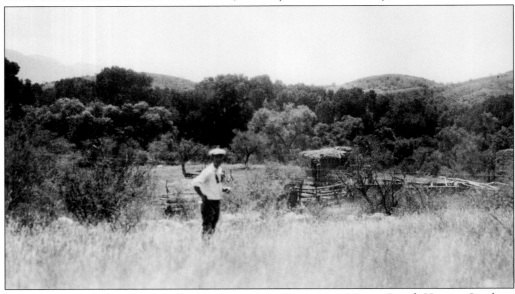

SANFORD HOMESTEAD. As described by Janet Ann Stewart in *Arizona Ranch Houses: Southern Territorial Styles 1867–1900*, the original adobe house "was constructed as a contiguous-room, flat-fronted building with an ell projecting toward the rear." Pictured in this late 1920s–early 1930s photograph is likely Carl Zinsmeister exploring remnants of Denton Sanford's ranch house overlooking the Sonoita Creek. Visible directly behind Zinsmeister is the adobe brick house at center. Also visible is a small corral. (Courtesy of the Nash family.)

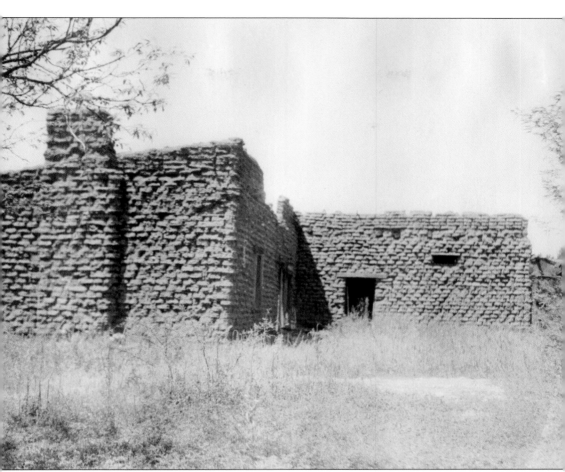

SANFORD RANCH HOUSE RUINS. This c. 1930s photograph shows the adobe ruins of the ranch house built and owned by prominent rancher Denton G. Sanford. This was Sanford's residence from the 1870s until his death in 1885. The feature that distinguished his dwelling from other territorial houses was the broad *zaguan* (breezeway) that was eight feet wide and cut through the center room. The zaguan was used as a lounging room and kitchen, with a Dutch oven for cooking and a long table with side benches for eating. (Courtesy of the Nash family.)

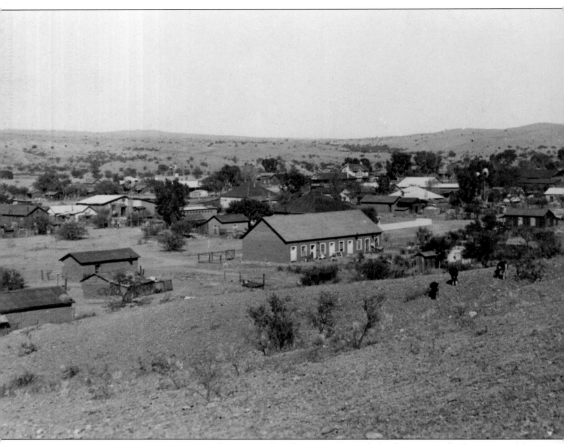

EARLY PATAGONIA. In 1888, Rollin R. Richardson purchased the homestead of James Ashburn at the foothills of the Chihuahuilla Mountains. Eight years later, the area was surveyed. An astute businessman, Richardson built a smelter nearby and sold parcels of land. In 1900, the post office was established. With the community voting to name the town Patagonia (the land of the big-footed people), the two-story train depot was erected. This photograph shows a partial view of Patagonia in the 1900s. The Dusquene House (center) faces the Santa Rita Mountains to the north. The railroad section of the foreman's house (far left) was built in 1904. Visible in front of the foreman's residence are the Patagonia Opera House and Cady Hall, established by pioneer John Cady. By 1929, Patagonia had grown in population and as a commerce center. (Courtesy of The Patagonia Museum.)

BLOXTON RAILROAD STATION. The Bloxton Station, once located northeast of Sanford Butte, was one of the many passenger stops on the New Mexico & Arizona Railroad. This railroad, built in 1881–1882, ran from Benson to Nogales and connected to the Sonora Railroad in Mexico. By 1910, railroad stops included Fairbank, Brookline, Campstone, Elgin, Fruitland, Perrin Trust Ranch House, Sonoita, Ashburn, Crittenden, Patagonia, Flux, Farallon, Bloxton, Sanfords, Fuller's Ranch, Calabasas, Plomo, Saxton, Benedict, Nogales (on the Arizona-Mexico border), and Nogales (in Mexico). In 1927, the railroad from Nogales to Patagonia was still operating. A severe rainstorm washed out the bridges in the summer of 1929. By 1930, the rail line south of Patagonia was abandoned. Since that time, Circle Z guests have used the empty railroad tracks as a trail for horseback riding. The concrete trestles for the railroad bridges crossing the creek still exist today. Pictured here is what remained of Bloxton Station in the 1920s. (Courtesy of the Nash family.)

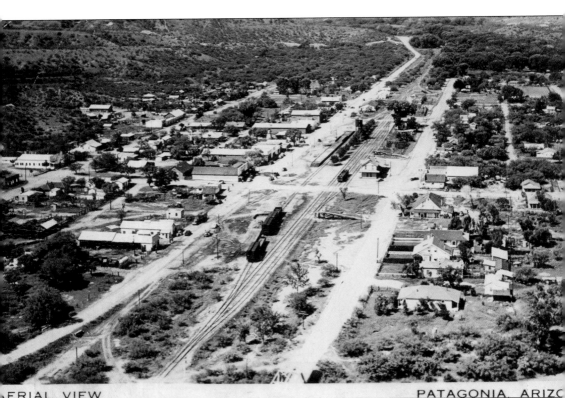

PATAGONIA, 1940s. Guests arriving by train from Chicago and New Orleans took the Southern Pacific Line to Tucson, stayed there overnight, and then took the morning train to Nogales, Arizona. There they were met by the Circle Z car and truck to be driven to the ranch. Some guests arrived at Circle Z via the New Mexico & Arizona Railroad. A portion of this rail route known as "the Burro" ran parallel to Sonoita Creek. Some guests arrived in private railway cars that remained on a siding near the Patagonia Train Depot. This postcard shows an aerial view of Patagonia. The wooden two-story train depot (left of the tracks) was located in the center of town. Patagonia was incorporated in 1948. (Courtesy of Gilbert Quiroga.)

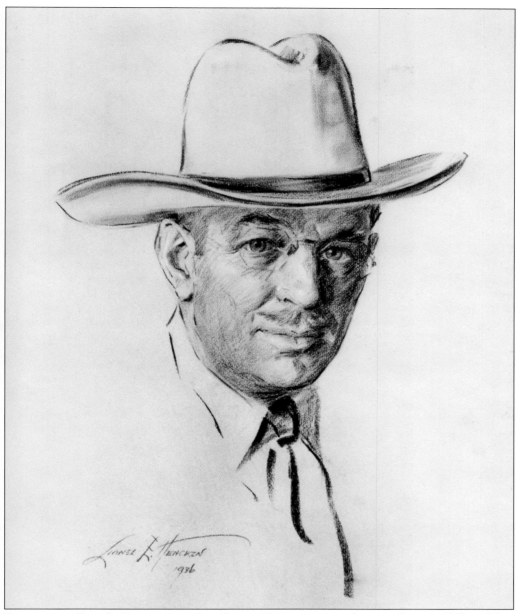

PORTRAIT OF LEE G. ZINSMEISTER. Lee George Zinsmeister was born on June 3, 1887, in New Albany, Indiana. He was the youngest of Jacob and Anna Zinsmeister's six children. Brothers Carl, Edward, and Lee were business managers and partners in their wealthy father's wholesale grocery business, J. Zinsmeister & Sons, in Louisville, Kentucky. Carl Frank Zinsmeister moved to Tucson with his family in 1915 to recover from chronic bronchitis. Lee Zinsmeister was 41 years old when he visited Carl in 1924. It was Lee Zinsmeister's idea to operate a guest ranch in Arizona cattle country. Later that year, Carl and Lee purchased the old Sanford Ranch from Bertha Sanford Miller. American artist Lionel Eberhard Hencken (1905–1968) of Clayton, Missouri, sketched this portrait of Lee Zinsmeister while he was a guest at the ranch in 1936. (Courtesy of the Bergier family.)

17

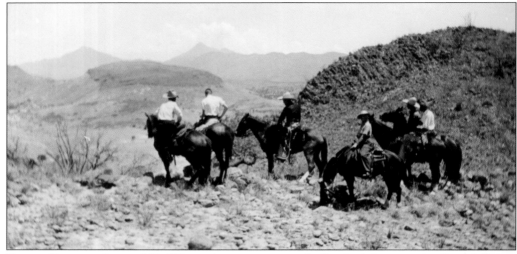

RANCH COUNTRY. Lee and Carl Zinsmeister were among the first in Arizona to visualize a full-time livestock operation and guest ranch. They worked hard to realize their dream of putting the "Z" in Circle Z Guest Ranch. At the time of purchase, the 5,000 acres of rangeland was a well-established cattle ranch known as Sanford's Aztec Ranch/97 Ranch. Lee believed the rugged terrain, with the winding creek and temperate climate, was ideal for horseback riding, exploration, and simple relaxation. Here a small riding party stops along a trail to view the grandeur of the Santa Rita Mountain landscape west of Circle Z. Ranch manager Sam W. Foster of Terrel, Texas, is at far left. In 1915, Foster moved to Patagonia at the age of 17. He cowboyed for foreman Jack Davis of the Rail X Ranch, owned by the Boices of the Chiricahua Ranches Company. He married his wife, Maude Foster, in 1934. They lived at Circle Z from 1934 to 1937 with their daughter, Mary, and son, Sam. (Courtesy of the Nash family.)

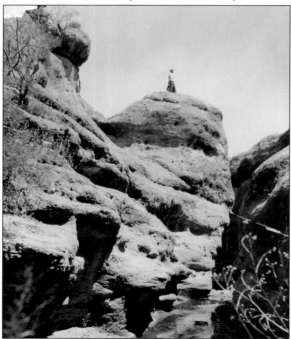

ROCK FORMATIONS. Rugged cliffs and unique rock formations create many spots of scenic beauty throughout the countryside surrounding the ranch. This c. 1936 photograph shows a boy atop the jagged-looking rock formations found along Sonoita Creek. (Courtesy of the Nash family.)

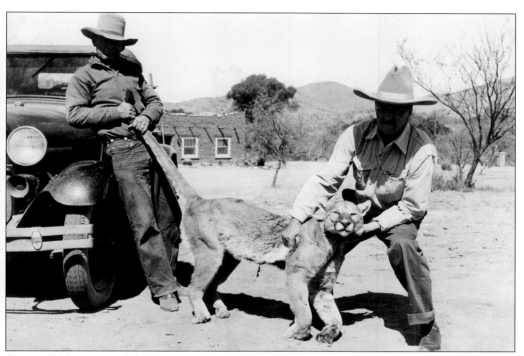

CIRCLE Z NEIGHBORS. The Zinsmeisters continued to operate Circle Z as a working cattle ranch. Robert Bergier and his wife, Willie Chapman Bergier, owned and operated both the Alto Ranch and the Hard Luck Ranch. The Hard Luck was the neighboring ranch just west of Circle Z on the other side of Sanford Butte about one and a half miles apart and near Bloxton, Arizona. The town of Bloxton was the birthplace of Bob and Willie Bergier's son, Ray. According to Ray Bergier, his dad bought the rangelands from his father-in-law. Today, grandsons Bob and Bill Bergier run the family's ranching operation. Above, neighbor Bob Bergier (left) pays Lee Zinsmeister a visit in this c. 1934 photograph. The 1930s postcard at right features Lee Zinsmeister's hunting hounds. (Above, courtesy of the Bergier family; right, courtesy of the Nash family.)

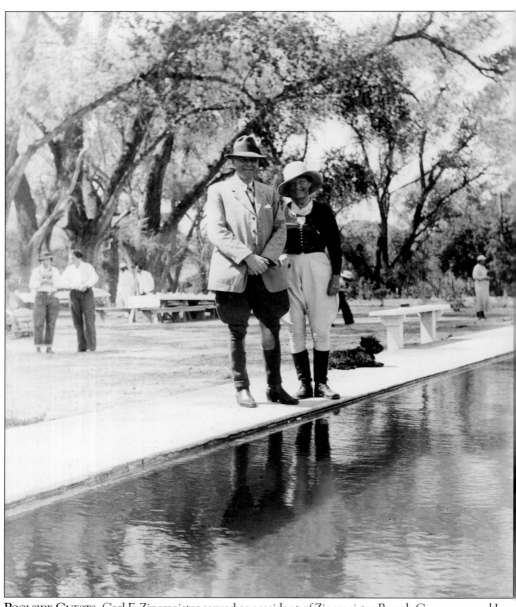

POOLSIDE GUESTS. Carl F. Zinsmeister served as president of Zinsmeister Ranch Company, and Lee G. Zinsmeister, as secretary, managed the details of the business. The guest booklet stated: "The owners and managers of the Circle 'Z' Ranch were prompted by the demands of discriminating people to turn this beautiful and well-established cattle ranch into a guest ranch of the very highest order, a place where people who are accustomed to the very best service, comfortable living conditions and a love of the out-of-doors, could spend their vacation or take a rest away from the hustle and turmoil of fashionable resorts and enjoy the novel experience of the life on a big cattle ranch without the many discomforts which are usually and necessarily forced on a ranch guest." In this 1930s photograph, guests pose for the camera as staff prepare for a picnic near the banks of Sonoita Creek. In the background at left are likely Helen and Lee Zinsmeister. Their Scottie dog relaxes on the pool deck. (Courtesy of the Nash family.)

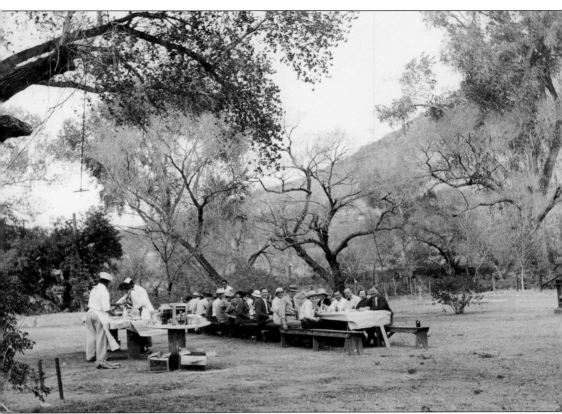

Afternoon Picnic. The Circle Z had one of the finest kitchens in the area. Fresh poultry, eggs, and vegetables and the purest dairy products were served daily. The dinner menu included a selection of fine foods from California, the Salt River Valley north of Tucson, and fresh vegetables and seafood from Mexico. Western-style picnics by the creek, pictured here, were popular. Regular dining experiences where garden-fresh vegetables and the best cuts of meat were prepared right from the grill were noteworthy. Top chefs were employed. Retired Pullman porters in white jackets waited on guests. Evening meals were served in the large, airy dining room in the main house. Two smaller dining rooms were available for private parties. Guests were served at separate tables covered with linen tablecloths. Children ate separately at a long table near the kitchen. (Courtesy of the Nash family.)

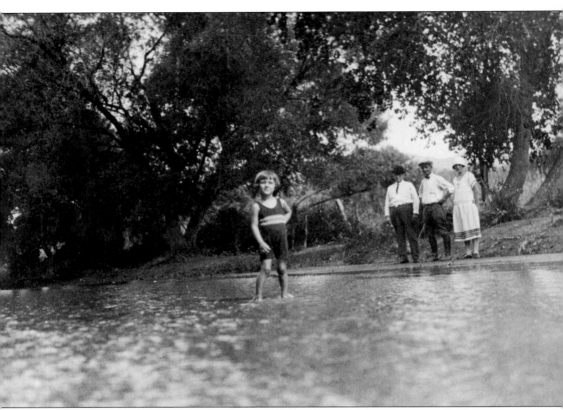

THE ZINSMEISTER FAMILY. Four-year-old Joanne Zinsmeister (left) wades in the original swimming pool, fed by the cool water of Sonoita Creek. Looking on attentively are, from left to right, grandfather Jacob Zinsmeister and parents Carl Zinsmeister and Nadine Weissinger Zinsmeister. Carl, Nadine, Joanne, and Lee lived in Patagonia in 1924 while supervising construction of the ranch buildings. Joanne's parents helped build the guest cottages. They moved to the Circle Z in 1926 with Joanne's uncle and grandfather for the grand opening. She attended Patagonia Grammar School through fourth grade and recalled how hard her mother worked to keep the kitchen going, preparing and serving the meals when they had 70 guests. After dissolving the family establishment in Louisville, Kentucky—J. Zinsmeister & Sons—and selling his home in New Albany, Indiana, Jacob Zinsmeister retired and moved to Patagonia in January 1927. (Courtesy of the Nash family.)

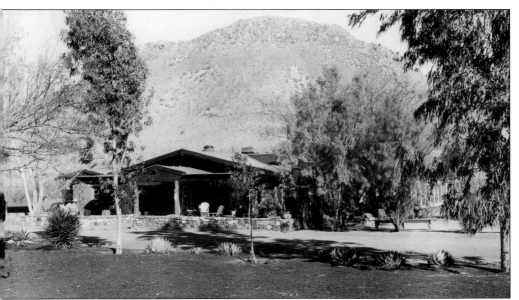

MAIN HOUSE AND ADOBE CARPORT. Carl and Lee Zinsmeister took much care in selecting the site of ranch headquarters. They hired John P. Burton, builder of the Nogales City Hall. The large adobe main ranch house, known as the "Big House," was centrally located. The ranch house and guest cottages faced a sweeping circular lawn with a cactus garden landscaped by Lee Zinsmeister. The interior had a large living room with two big bookcases, comfortable couches, and an oversized stone fireplace. The library contained many books including popular adventure novels and stories by Western genre author Zane Grey. After dinner, guests gathered in the living room to play cards, listen to the radio or Victrola, and play the grand piano. Later, a ping-pong table was added. (Both, courtesy of the Nash family.)

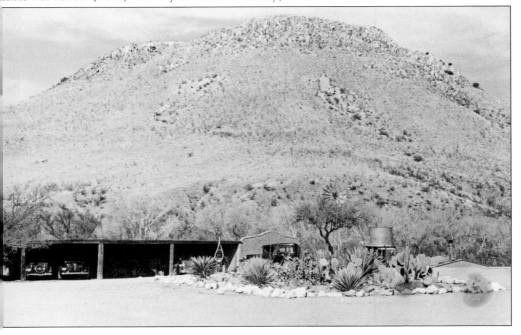

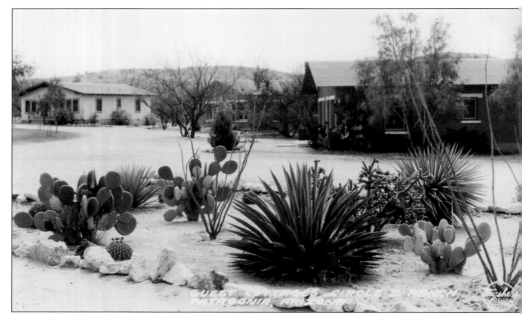

GUEST ACCOMMODATIONS. Patagonia's first dude ranch opened in 1926 with limited accommodations for 24. This was not the rustic dude ranch operations of the 1920s and 1930s, where Easterners had to rough it. The two adobe brick and one wood-paneled guest cottages pictured were conveniently grouped near the Big House but far enough away to maintain quiet and privacy. Each had four rooms with hardwood floors, electric lighting, and indoor plumbing, and was heated by thermostatically controlled steam boilers. The cottages were designed so that each bedroom had a private entrance from the outside. (Courtesy of the Nash family.)

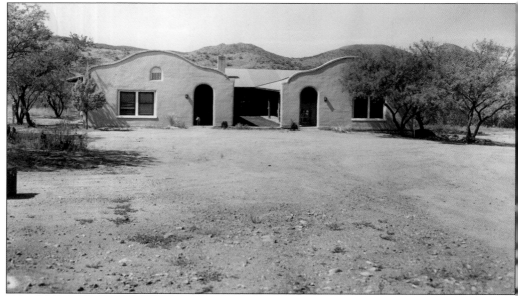

CASA ROSA. Casa Rosa was an eight-room guest hacienda built in the mid-1930s. Each room led onto a patio and courtyard and had a private bath with hot and cold running water. The house could accommodate 16 guests. (Courtesy of the Nash family.)

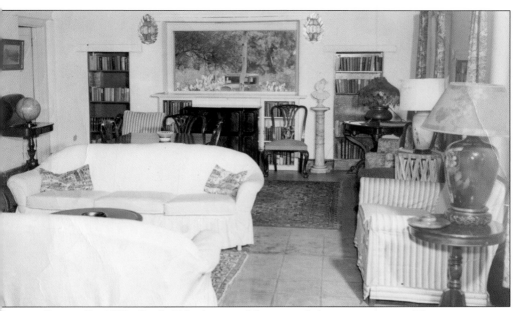

LIVING ROOM. By 1933, Circle Z had opened for its eighth winter season. The management annually increased its facilities to accommodate a capacity of 70 guests. There were several types of living accommodations available, from a four-room cottage having two rooms with baths to a three-bedroom family cottage with two baths and a sitting room. A Ford Model T can be seen through the large window of the Zinsmeisters' living room. (Courtesy of the Nash family.)

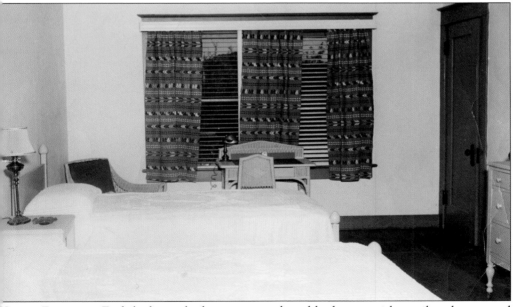

GUEST BEDROOM. Each bedroom had a private or shared bathroom with a toilet, shower, and bathtub with hot and cold running water. The well-furnished rooms were simple but comfortable and included two single beds or a double bed with high-quality mattresses, a dresser, a writing desk, and comfortable wicker furniture. Every bedroom had two or three windows for good ventilation, and a separate entrance. (Courtesy of the Bergier family.)

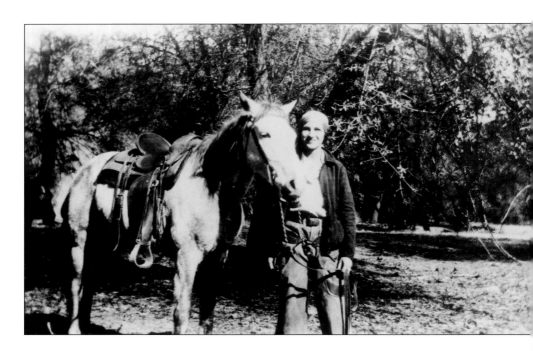

HELEN KELLER ZINSMEISTER. Helen T. Keller was born in Denver, Colorado, on August 12 1900. She was one of Charles and Susan Keller's three children. The Keller family, well-known merchants, owned grocery stores in New Albany, Indiana, and Louisville, Kentucky. The Keller family moved to Los Angeles when Helen was five years old. She was a journalism major at Ohio State University and member of Alpha Phi sorority. In 1922, she returned to Los Angeles, where she joined the California Bank. Five years later, she became chairwoman of the bank's Women's Affairs Committee. Lee G. Zinsmeister married Helen on August 15, 1928, in Beverly Hills. She poses with her horse in the c. 1930 photograph above. Below, she delights in the antics of her pet deer and Scottie dog while Lee's Airedale relaxes nearby. (Both, courtesy of the Nash family.)

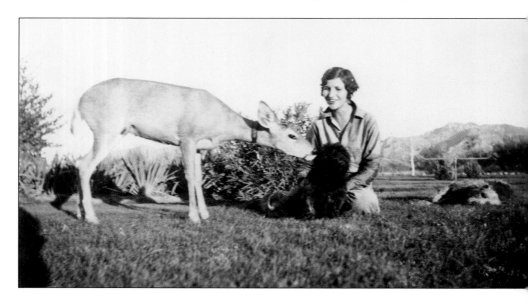

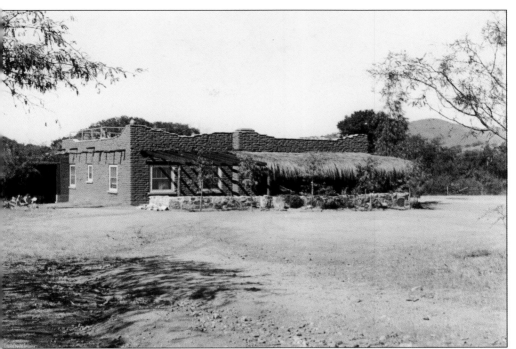

ZINSMEISTER RESIDENCE. Lee's father, Jacob Zinsmeister, died on September 16, 1928, one month after Helen married Lee and made Circle Z her home. The couple soon learned that Carl and Nadine Zinsmeister no longer liked the work on the ranch. Lee and Helen bought out Carl's interest in the ranch and made extensive improvements and additions to Circle Z. They were the sole resident owners and managers of Zinsmeister Ranch Company Inc. The traditional-style adobe brick building seen in the c. 1926 photograph above was the private home of Lee and Helen Zinsmeister. The interior of their home had a massive stone fireplace and two large bookcases, filled to the top with books, along the walls in the living room. Lee Zinsmeister is shown below on his mount at his residence in front of Circle Z Mountain, the sentinel of the old Sanford house. (Both, courtesy of the Nash family.)

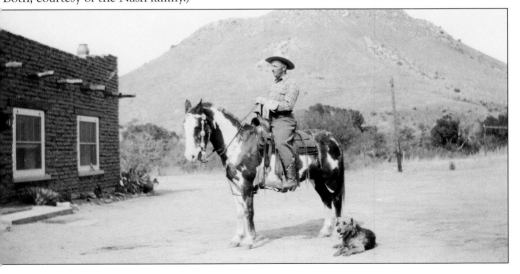

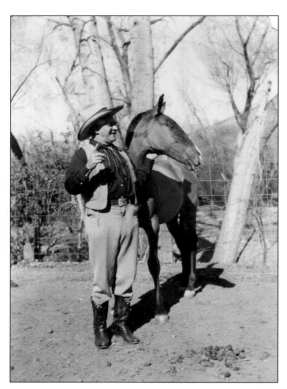

GUEST ATTIRE. Guests were encouraged to bring a small wardrobe of clothing suitable for the outdoors. Blue jeans, long-sleeve shirts, a warm jacket or sweater, boots, and a wide-brimmed hat were recommended for daily horseback riding. Some of the guests went all-out, wearing fancy Western boots, expensive Stetsons, and chaps. Nice casual and sports clothing was suggested for dining and social gatherings. (Courtesy of the Nash family.)

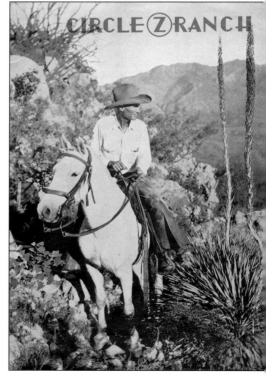

GUEST BOOKLET, 1930s. Lee Zinsmeister hired Sam Foster as ranch foreman in 1933. New guests were carefully selected based on their references. The restrictions in the 1936 booklet, featuring Sam Foster on the cover, stipulated: "No one is accepted who is affected with a communicable disease. We reserve the right to terminate the visit of any guest or party whom we consider not up to the standards which we endeavor to maintain. We are forced to make a ruling against guests bringing dogs to the ranch because of the numerous complaints from other guests." (Courtesy of the Nash family.)

THE WEAVER FAMILY. Mr. and Mrs. Robert A. Weaver of Cleveland, Ohio, and their children, Charlotte, Robert, and Peter, were regular winter-season guests from 1929 to 1946. Weaver saw an advertisement for Circle Z in the Delta Tau Delta alumni magazine. Lee Zinsmeister had graduated from Purdue University, where he studied chemical engineering and belonged to the Delta Tau Delta fraternity. Pictured from left to right are Peter, Bob Jr., and Bob Sr. (Courtesy of the Nash family.)

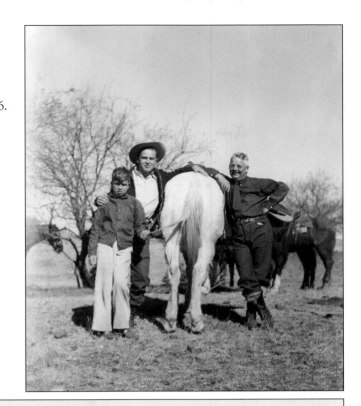

Mr. & Mrs. Lee Zinsmeister

Announce

The Opening of the Eleventh
Winter Season

of

CIRCLE Z RANCH

on

OCTOBER FIRST

WINTER SEASON INVITATION, 1936–1937. The program of the 1929 Fourth of July Patagonia Rodeo and Barbecue stated: "Circle Z Guest Ranch is the most outstanding winter ranch resort in the state of Arizona. Its excellent accommodations and service are contrasted during the day with a rugged out-of-door life. It is the place where the very highest class people come to enjoy the splendid winter climate and enter into the healthful ranch activities and yet live as comfortably as in their own home." Pictured here are Lee and Helen Zinsmeister on an invitation announcing the opening of the 11th winter season at Circle Z Guest Ranch. (Courtesy of the Nash family.)

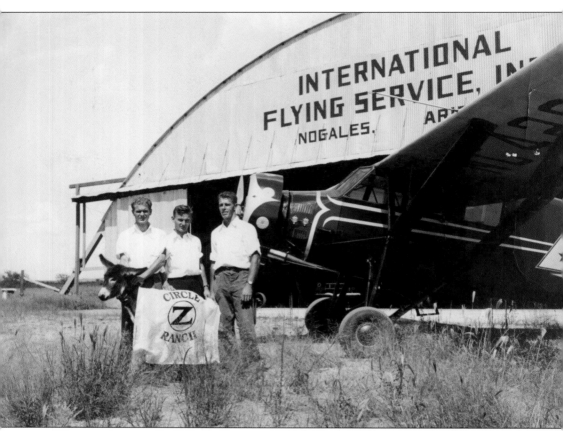

NOGALES AIRPORT. By 1941, the Zinsmeisters had entertained more than 2,500 guests from 14 states, Canada, England, and other countries. Many guests returned to the Circle Z Guest Ranch year after year for an average of one month. In the 1920s and 1930s, most guests arrived at the ranch by passenger rail service. Some guests, however, reached the ranch by private car. The Standard Air Lines and the Pickwick–Latin American Airways provided regular service from Tucson to the Nogales Airport. This image shows three young men standing near a small plane parked in front of a hangar at the airport, located about 10 miles from the ranch. The border town of Nogales, Mexico, was a favorite destination. Guests would walk across the international border to shop and enjoy dinner at La Caverna restaurant (the Cave). (Courtesy of the Bergier family.)

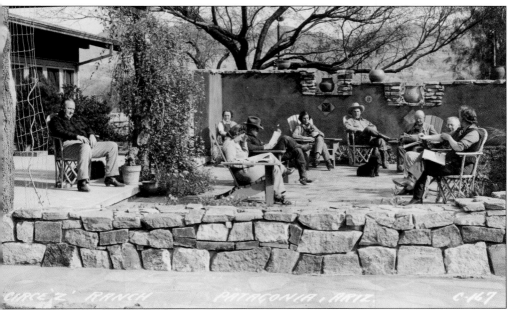

GUESTS RELAXING. Prominent guests were common at the ranch, including Dame Sibyl Hathaway of Great Britain; financier and philanthropist John D. Rockefeller Jr. of New York and his wife; visual artist Lionel E. Hencken of St. Louis, Missouri; and industrialist Kelvin Smith, his wife, Eleanor, and their daughters, Cora and Lucia (Nash) of Cleveland, Ohio. Some families remained for the entire winter season, October 1 to May 15. In the 1930s postcard above, Helen Zinsmeister holds a puppy and Lee Zinsmeister reads a newspaper while they enjoy the warm February sunshine with their guests on the sun porch of the main house. Benches, swings, and hammocks were strategically placed creekside for guests to relax under the shade of the cottonwood trees. (Both, courtesy of the Nash family.)

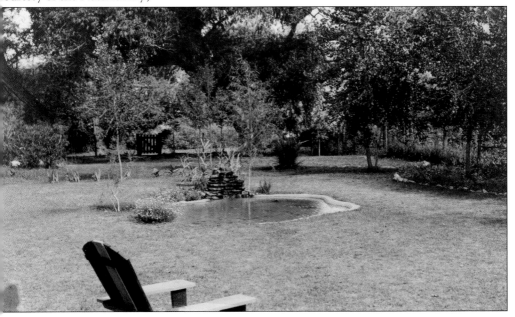

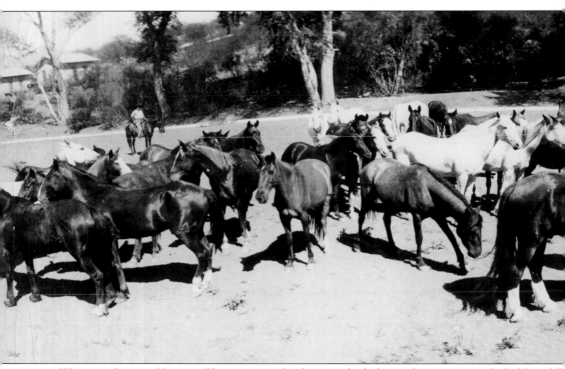

Western Saddle Horses. The most popular feature of a dude ranch is its string of reliable saddl[e] horses. The Zinsmeisters maintained an excellent string, or *remuda*, of 100 horses, mostly bre[d] and trained on the ranch. Experienced cowboy-wranglers were always an important part of th[e] ranch. Most guests said the wranglers were "the heroes of Circle Z." A wrangler is a cowhand wh[o] takes care of the saddle horses. The owners of Circle Z employed local cowboys who were bot[h] expert cowhands and personable to be guides on trail rides, teach guests good horsemanshi[p]

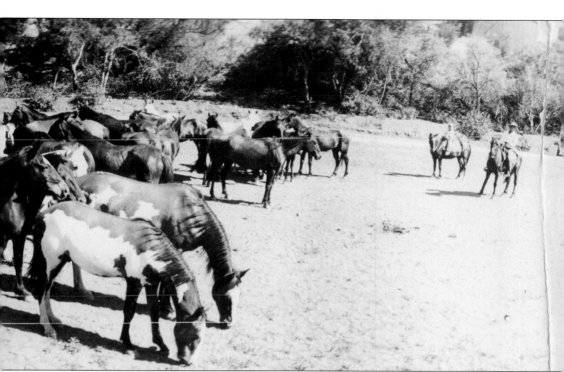

and ensure the safety and comfort of guests at all times. Some guests welcomed the opportunity to ride along with the ranch cowboys. They tried their hand at calf branding, learned to round up horses, and saw first-hand how wranglers broke colts to be ridden. This 1930s image shows wranglers and guests (background) bringing in the remuda to the ranch corral by the Circle Z rodeo grounds and polo fields. (Courtesy of the Nash family.)

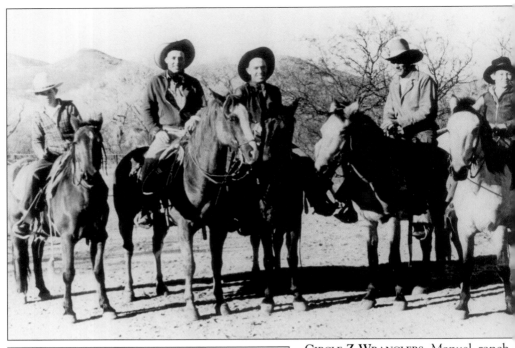

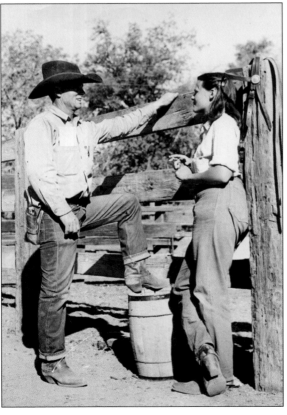

CIRCLE Z WRANGLERS. Manuel, ranch foreman Ronquillo's son, was one of the first cowboy-wranglers at the ranch. Wranglers Grover Kane, Bob Kane's nephew, and Paul Kane, Joe Kane's son, worked regularly at the ranch. Grover Kane was appointed Patagonia's first official town marshal when the town incorporated. Other cowboys employed by the Zinsmeisters were Sy Swyers, world champion steer roper Marvin "Buckshot" Sorrells, his brother Hyra "Hi" Sorrells, Arch King, and Norman Kane. In the early 1930s photograph above are, from left to right, Don (young boy), Buckshot Sorrells, Arch King, Sam Foster, and an unidentified boy. When interviewed in 1978 about being a Circle Z wrangler in 1926, local rancher Blaine Lewis, pictured at left at the Circle Z corrals, said: "Carl and Lee Zinsmeister were Easterners; bought it to be a dude ranch. They [guests] came out from the East to ride and play cowboy." Lewis was called the last of the true old-time cowboys. He is best known, however, as the deputy she for 10 years and the Patagonia town constable. (Above, courtesy of the Nas family; left, courtesy of the Bergier fam)

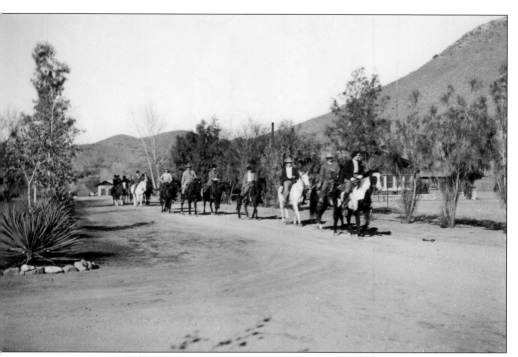

MORNING TRAIL RIDE. Riding horses was the chief diversion for the majority of guests. Upon arrival, the ranch manager chose a horse and saddle best suited to the guest's riding experience and comfort. There were unlimited miles of trails leading from the ranch. Some guests rode several times during the day. All-day cowboy cookout rides and moonlight rides were arranged weekly. Near the cottages was a half-mile riding track for those preferring to take a short ride or practice riding. Pictured here is a trail party riding by the main house. (Courtesy of the Nash family.)

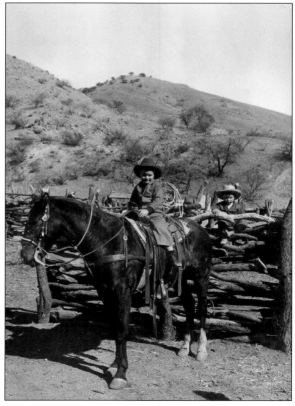

CHILDREN RIDERS. Two experienced cowboys worked as wranglers to instruct and guide guests at all times. Children three years of age and older were given special attention. The two children in this postcard are saddled up and ready to ride under the watchful eyes of a wrangler. (Courtesy of the Nash family.)

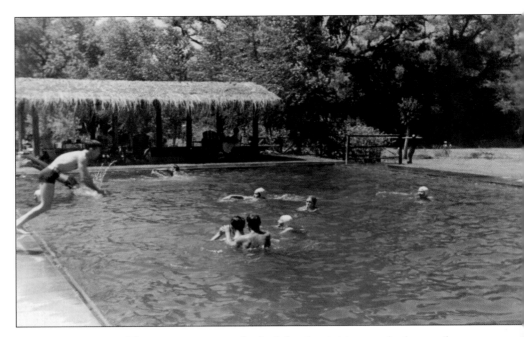

OTHER DIVERSIONS. There was no required schedule of activities—only the carefree one a gues wished to follow. Tennis, shuffleboard, badminton, target shooting, seasonal hunting, croquet horseshoes, and quoits (a traditional ring toss game similar to horseshoes) were the activitie offered. The large concrete swimming pool shown here was four feet deep in the shallow end and eight feet deep at the far end. A smaller, heated swimming pool and putting green were added in the late 1930s, built close to the main house and near guest accommodations. (Above, courtesy of the Nash family; below, courtesy of the Bergier family.)

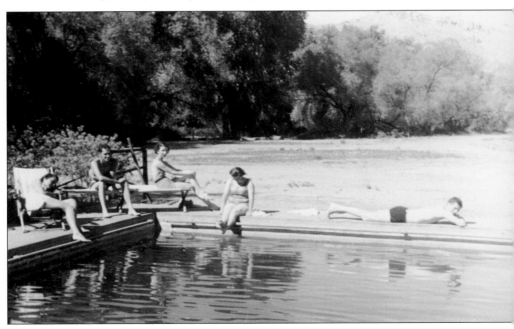

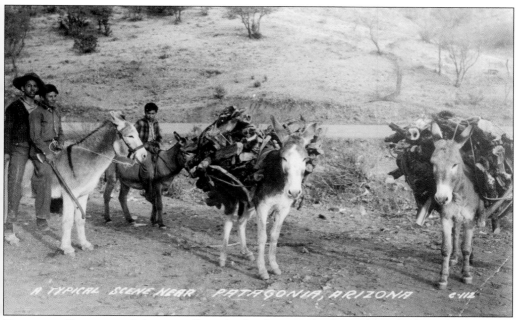

PATAGONIA POSTCARD. A favorite of horseback riders was the five-mile trail ride to the charming Western town of Patagonia. Many Circle Z guests frequented the Showalter Saddle and Gun Shop. Roy Salge made many Western saddles with silverwork by Paul Showalter for the ranch. Pictured are several local boys on burros from the mines. (Courtesy of The Patagonia Museum.)

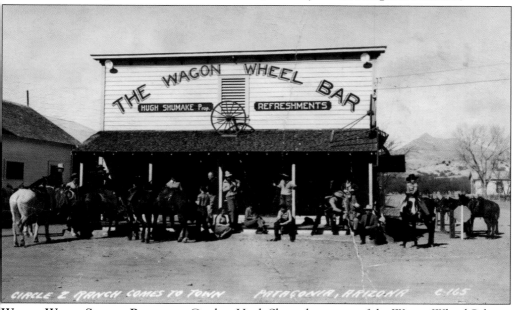

WAGON WHEEL SALOON POSTCARD. Cowboy Hugh Shumake, owner of the Wagon Wheel Saloon, bought the bar during Prohibition in 1927. He advertised that his bar was the place locals gathered to meet their friends and where only the finest wines, liquor, and beer were sold. The Wagon Wheel and the Big Steer Bar and Grill, owned by Dawson Scoggins, were favorite respites for the locals and Circle Z guests, known as "dudes" by the locals. (Courtesy of the Nash family.)

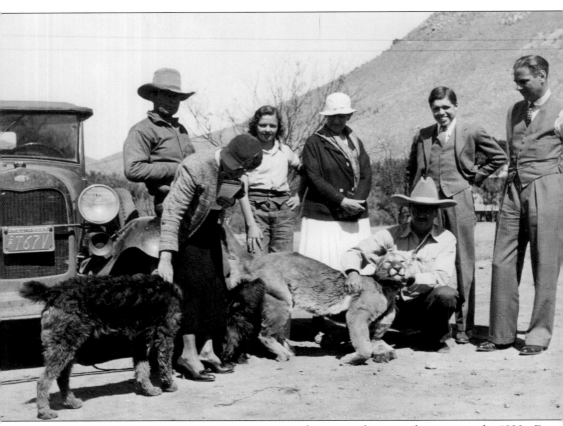

MOUNTAIN LION HUNTING. Hunting was a popular seasonal activity for guests in the 1930s. Deer season was from October 15 to November 15. Special arrangements were made for guests interested in hunting mountain lion, wolf, and bear in the Santa Rita Mountains. Lee Zinsmeister would take guests who were experienced riders with him to hunt mountain lions with his hounds. Bob Bergier had four hounds he used to tree mountain lions. Lee Zinsmeister had a trained parrot that he kept on the porch of his home. The parrot was able to imitate Lee's voice so well that the hounds would bark like mad. Shown here are, from left to right, (first row) Helen Zinsmeister and Lee Zinsmeister; (second row) Bob Bergier, daughter Edith Bergier, and unidentified guests. The Circle Z no longer supports hunting. (Courtesy of the Bergier family.)

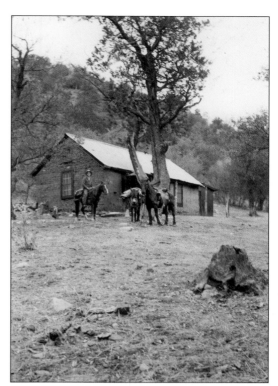

MOUNTAIN CABIN. The Zinsmeisters maintained a rustic cabin in the Santa Rita Mountains for guests who wished to go hunting and spend time in a more remote setting. Pack trips to the cabin could be arranged quickly with no additional cost for guide or cook. The 1930s photograph at right shows a full view of the cabin. A man waits on his mount with a pack burro and saddle horse. The cabin was 20 miles from the ranch at the base of Mount Baldy, the highest peak in the Santa Rita Mountains, and could only be reached on horseback. The pack trip was a three-day journey. Shown in the early 1930s photograph below are guides Helen Zinsmeister and Don Farrell in front of the mountain cabin. (Both, courtesy of the Nash family.)

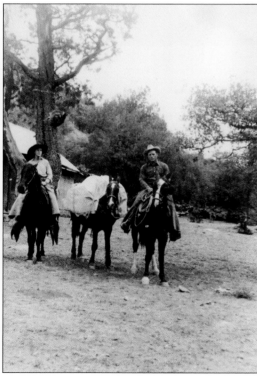

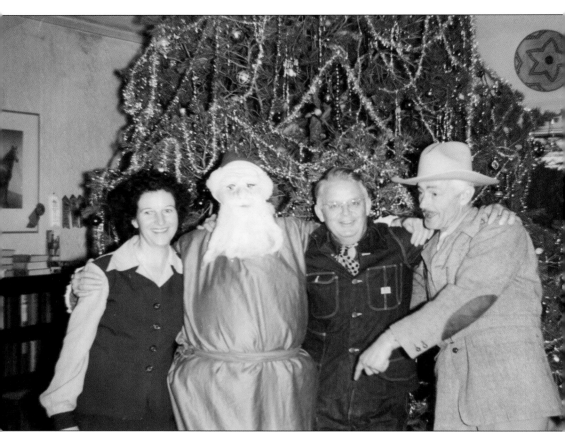

CHRISTMAS FESTIVITIES. The Christmas and New Year's holidays were a special time at Circle Z. Since Lee Zinsmeister was artistic, he was charged with attending to all the decorations, entertainment, and program activities. The festivities began with the tree trimming party in the main living room. The traditional yule log was lit after the tree was decorated and garland and mistletoe were hung. The December 31, 1938, Nogales *Daily Herald* reported: "With bells jingling, Santa Claus (Bruce Nichols of Santa Barbara) arrived at 10 o'clock Christmas morning. He drove through the ranch and up to the main ranch house in a highly decorated old Mexican cart drawn by burros. The cart was laden with sacks of gifts, which were distributed at the Christmas tree to the assembly of guests, employees, their families and a number of neighbors." Shown here from left to right are Helen Zinsmeister, Bruce Nichols, Robert Weaver, and Lee Zinsmeister. (Courtesy of the Nash family.)

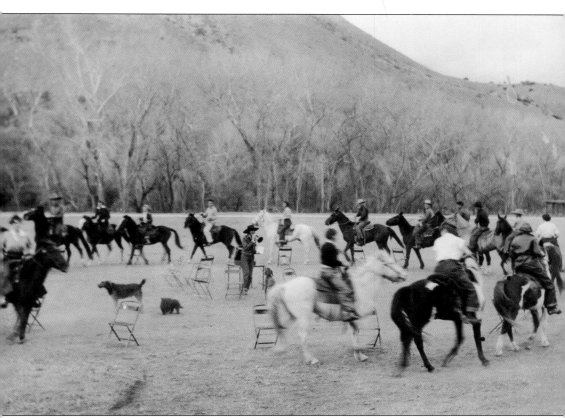

HOLIDAY GYMKHANA. The Zinsmeisters hosted the Christmas Day dinner in the beautifully decorated dining room of the main house. In the evening, they received their guests and invited friends and family to their home, where a Mexican *charro* band played. Helen Zinsmeister arranged many special riding activities and contests during the holiday week. Typically, activities included an all-day ride with lunch in the mountains, a *gymkhana* for guests to play games, and a relay race held by the cowboys. It was customary also for Lee and Helen to host a New Year's Eve party in the dining room. The week culminated with a New Year's Eve dinner dance, accompanied by a cowboy band. In this late 1930s photograph, Helen Zinsmeister directs riders in a game of musical chairs played on horseback at the Saturday gymkhana. (Courtesy of the Bergier family.)

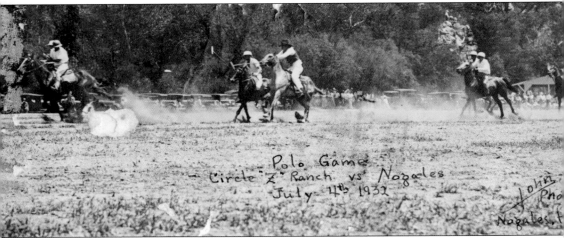

Within the photograph (handwritten): Polo Game Circle "Z" Ranch vs. Nogales July 4th 1932 John Pho Nogales

POLO MATCH. Playing polo at Circle Z Ranch began in the 1930s, after ranch guest Colonel Beasley, who stayed at the ranch for several seasons, introduced the game to Circle Z cowboys and guests. The cowboys were naturals. The flatland west of the corrals was designated as the ranch rodeo and polo field. The Circle Z Wranglers polo team competed regularly. They played for four years and defeated fine teams such as the University of Arizona, Fort Huachuca, Riviera in Santa Monica, and the New Mexico Military Institute in Roswell. Helen Zinsmeister explained, "We began playing polo in the 1930s and played until Roosevelt [Franklin D. Roosevelt] put us on gas rationing [during the Great Depression] and we could no longer take our horses any place." This photograph of the team was taken at the polo match in Nogales, Arizona, on July 4, 1932. (Courtesy of the Nash family.)

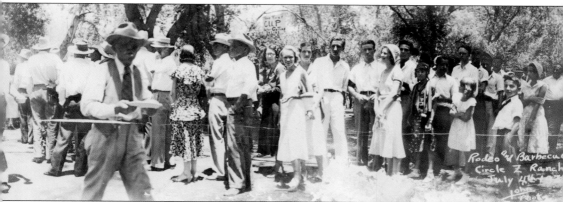

FOURTH OF JULY PATAGONIA RODEO AND BARBECUE. By 1929, the annual Fourth of July Rodeo and Barbecue, held at Circle Z, was the biggest community celebration in Santa Cruz County, with up to 2,000 people in attendance. Admission was $1 for adults and 50¢ for children. The event drew top rodeo performers from southern Arizona. The Patagonia Volunteer Firemen sponsored this family event. Every year, seven steers were barbecued. Families came from all over southern Arizona to sit under the big cottonwoods on the banks of the creek to eat tasty pit barbecue and beans and to see the crowd-pleasing rodeo contests at the Circle Z Rodeo Grounds. The 1929 program listed the following schedule of events: 11:00 a.m., address by James P. Boyle; 12:00 p.m., barbecue and band concert by the 25th Infantry Band; 1:30 p.m., rodeo; and 8:00 p.m., dance at the Patagonia Opera House. Above, attendees at the 1932 Fourth of July Patagonia Rodeo and Barbecue socialize as they stand in line for a helping of pit barbecue and the fixings. (Courtesy of the Nash family.)

CIRCLE Z RODEO AND BARBECUE. By the 1920s and 1930s, rodeos were a popular national sporting event. Circle Z rodeos were held regularly on Sunday afternoons and were well known in Arizona. Rancher Blaine Lewis recalled that there were always big rodeos in Patagonia at the Circle Z Ranch. Local ranches loaned calves and steers for roping and bronco riding. The Lewis Ranch was northeast of Red Mountain in Patagonia. Longtime Patagonian Jane Swyers remembers helping her father, Sy Swyers, a Circle Z cowboy at the time, cook steak, potatoes, and barbecue on their barbecue pit at the ranch for the rodeos and picnics in the 1940s. She did all the baking at these events because her dad "always entertained the dudes from Circle Z." Every year, Lee Zinsmeister invited as many as 500 members of the Arizona Scottish Rite and their families to the ranch for a special barbecue and a full day of swimming in the pool. (Courtesy of the Nash family.)

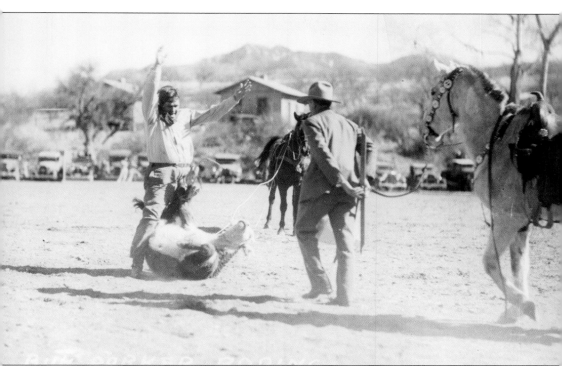

BUD PARKER POSTCARD. The Depression and a three-year drought compromised the condition of livestock and put an end to the Fourth of July Patagonia Rodeo and Barbecue at the ranch in 1932. Lee G. Zinsmeister was the chairman of the rodeo committee and rodeo director from 1926 to 1932. The rodeo event, name of contestant, and roping time were announced over the loudspeaker. Featured events included a cigar race, calf roping, wild horse riding, wild mule riding, and bronco riding. Here, rodeo official Lee Zinsmeister (right) leads his horse towards the contestant. The postcard image depicts an enthusiastic Bud Parker after he roped a calf in record time at the 1929 rodeo. Rancher Bud Parker, a well-known horse breeder and trainer, was a champion calf and steer roper. He supplied steers and bulls to contractors in the rodeo circuit as well. The pioneer Parker family settled in Lyle Canyon near Canelo in the 1880s to establish a working cattle ranch that continues today in what is known as Parker Canyon. (Courtesy of the Nash family.)

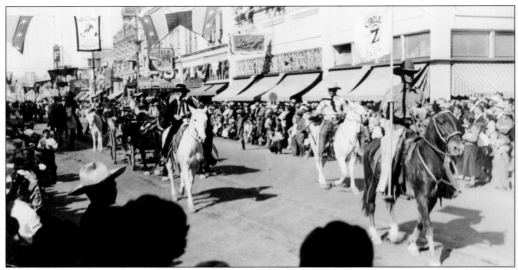

La Fiesta De Los Vaqueros Parade and Tucson Rodeo. La Fiesta de Los Vaqueros (the Celebration of the Cowboys) was first held in conjunction with the Tucson Mid-Winter Rodeo on February 21–23, 1925. The Tucson Rodeo became one of the top four rodeos in the nation. Winter visitor Leighton Kramer, president of the Arizona Polo Association, envisioned that the parade would attract tourists to the frontier town of Tucson. On the day of this first parade, thousands of spectators lined the downtown route to watch the 300 participants on horseback representing local cattle ranches and polo teams. Lee Zinsmeister's personal attention to Circle Z entries won first prize in the guest ranch section in 1935, 1936, and 1937. He often took as many as 50 guests to the parade. The c. 1937 photograph above shows Don Farrell holding the flag as he leads Circle Z's winning entry, Tally-ho, down the parade route. Shown below around 1935 are guests riding in the surrey dressed in authentic costumes of the early days. (Both, courtesy of the Bergier family.)

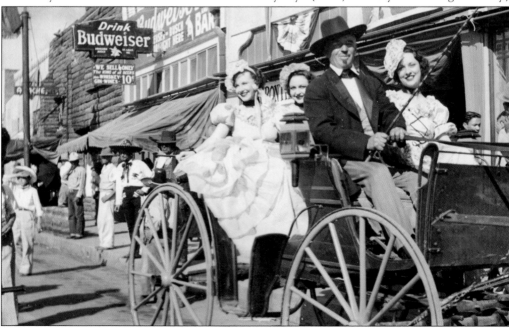

HELEN ZINSMEISTER AT HOME. Lee and Helen Zinsmeister adopted a son in 1944. Pictured at right with Helen is their infant son William John Zinsmeister. The travel and resort business was hit hard by the world war in Europe from 1939 to 1945. The Zinsmeisters invited business groups to the ranch in their efforts to offset the economic downturn. In her reply to a letter from Charlotte Weaver Jones, Helen commented that the 18 years she spent on Circle Z Ranch with Lee, Billie, staff, and guests "were the happiest days of our lives." Below, Helen bottle-feeds a pet fawn on the sun porch of the Zinsmeister residence at the guest ranch. (Both, courtesy of the Nash family.)

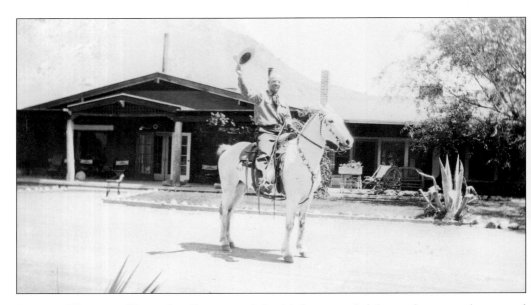

LEE AND HELEN AT HOME. Lee Zinsmeister's health began to fail from a heart condition, and the Zinsmeisters had to say farewell to their beloved Circle Z. In December 1946, the couple sold their interest in the ranch to Douglas and Micheline Robinson of Tucson. In a Christmas card, Helen Zinsmeister wrote to a friend: "We are selling the ranch and renting Lucy Steven's house in Patagonia for the winter. Best wishes to you both, Helen, Lee and Bill." Above, Lee Zinsmeister poses with his horse in front of the main ranch house. Pictured in the c. 1930s photograph below is Helen Zinsmeister in the corral with two colts that were bred and trained on the ranch. (Above, courtesy of the Nash family; below, courtesy of the Bergier family.)

LEE AND HELEN ZINSMEISTER. In the spring of 1947, Lee and Helen Zinsmeister purchased Lucky Hills Ranch near Tombstone as their second home. The cattle ranch was known as the Ernest Escapule Ranch. Lee Zinsmeister died on November 22, 1948, at the Veterans Hospital in Tucson. He was 61 years old. Zinsmeister was a World War I veteran, and was president of the National Coffee Roasters Association before he came to Arizona. For many years, he served as vice president and director of the Arizona Hotel Association. Two years after her husband's death, Helen K. Zinsmeister sold the Lucky Hills Ranch to Franklin M. Doan of Tom's River, New Jersey. Doan lived in Tucson at the time. As a teen, he spent Christmas vacations at Circle Z when a student at Greenfields School, a private boarding school in Tucson. According to the *Tucson Daily Citizen*, the 23,000-acre cattle ranch was purchased for $86,500. The cattle were sold separately at market price. Lee and Helen Zinsmeister pose on the lawn of the main house around the 1940s. The carport (left) and bunk house (right) are seen against the backdrop of Circle Z Mountain. (Courtesy of the Nash family.)

ARIZONA GUEST RANCH PIONEERS. Helen and son Bill left the state for Southern California. Over the years, Helen Zinsmeister lived in San Clemente, Laguna Hills, and Shell Beach. In her late 80s, she moved to West Lafayette, Indiana, to be closer to her son Dr. William Zinsmeister and his family. She died shortly afterwards, on June 15, 1990, at the age of 89. Lee and Helen Zinsmeister ran what became the oldest, largest, and most popular guest ranch in Arizona. For 18 years, the Zinsmeisters entertained over 5,000 guests from all parts of the United States and all over the world. Together, they maintained the atmosphere and traditions of the early West with the simplicity of a family-style ranch near the frontier town of Patagonia. In this late 1930s photograph, Lee and Helen Zinsmeister pose with the renowned Circle Z stallion El Sultan and his offspring at the entrance to the Circle Z Guest Ranch. (Courtesy of the Nash family.)

Two

PRIDE OF CIRCLE Z

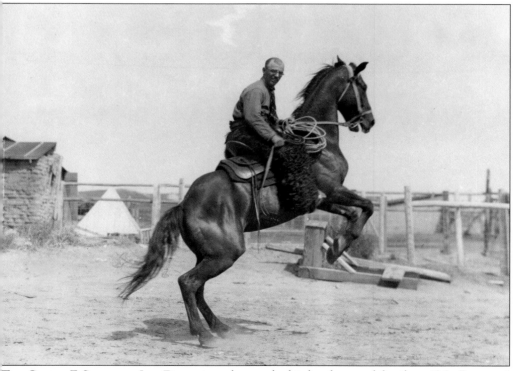

THE CIRCLE Z STALLION. Lee Zinsmeister, known by his brothers and family as "Mr. Barnum," demonstrates his showmanship with the aristocratic El Sultan. The Spanish sire was a Carthusian stallion bred in the famed stables of the Marquis de Domecq near Seville, Spain. The Carthusian breed is one of the oldest in the world, dating to the late 1200s. (Courtesy of the Nash family.)

PORTRAIT OF THE SPANISH STALLION. To establish the breed, Carthusian monks in Andalusia bred large Moorish Arabians with Northern European mares. By the 1500s, the breed was established. The monks called the breed *caballo santo* (saintly horse) because of its origin within the church and gentle nature. For centuries, the breed was used by the Spanish to produce cavalry horses. After the monks ended their breeding of the stallions in 1866, the Marquis Pedro de Domecq of Jerez purchased the entire Carthusian stables and the breed from the government as his sole property. For generations, the Domecq family protected the lineage of the "pura raza Española Cartuana" (purebred Spanish Carthusian). Carthusian-bred cavalry horses may have arrived in the United States via Mexico when Spanish missionary Fray Marcos de Niza entered the San Rafael Valley in 1539. El Sultan is pictured in these photographs taken in the late 1930s. (Both, courtesy of the Nash family.)

EL SULTAN AT CIRCLE Z. The story of El Sultan began in Havana, Cuba, three months before the overthrow of the Spanish monarchy. In January 1931, the royal house of Spain presented a brood mare in foal to Dr. A.S. de Bustamante. He was the owner of a prominent horse stable in Havana and a member of the World Court of Cuba. El Sultan was born two months later, on March 1. By the spring of 1934, the three-year-old arrived in New York City as a gift from Bustamante to attorney Wilbur "Bud" Cummings in appreciation for his work helping negotiate a deal between the Cuban sugar workers and American sugar refineries. There were only a small number of Spanish Carthusian stallions to leave Spain. The British Raj or Crown Rule in India purchased two in 1937 at a cost of $16,000. By 1938, there were two in England and one in Argentina. Above, El Sultan arrived at the ranch one month before he turned five years old. Pictured below is Lee Zinsmeister on El Sultan riding from the corrals near the Zinsmeisters' home. (Both, courtesy of the Nash family.)

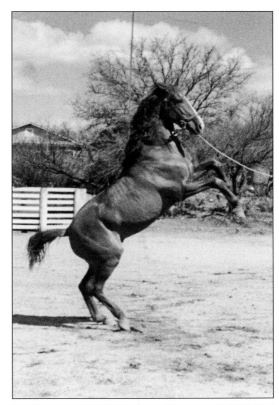

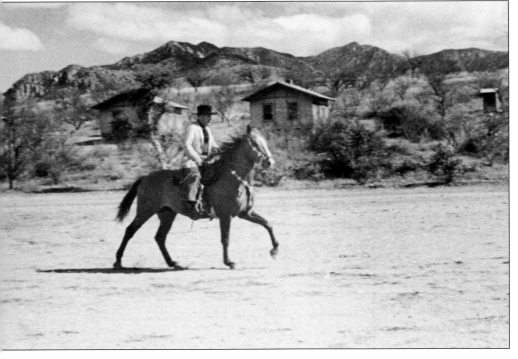

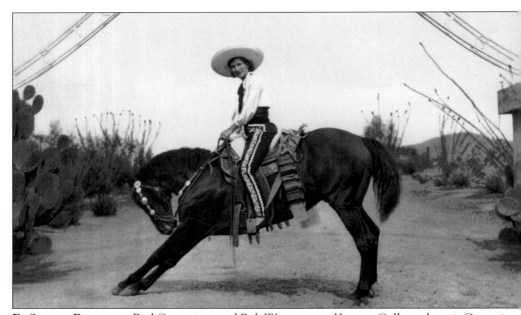

EL SULTAN PERFORMS. Bud Cummings and Bob Weaver were Kenyon College alumni. Cummings presented El Sultan to Weaver's wife when El Sultan was about three years old. Zinsmeister explained, "The colt [El Sultan] was sent to Kenyon College where Cummings and Bob Weaver were directors and given to Bob for a top polo string for the college. Bob felt he would be a wonderful addition to Circle Z as well as sire for a fine string of saddle horses so he gave him to us. We sent a horse trailer back to Ohio and brought him back (he was insured for $10,000 then)." In the c. 1935 photograph above, El Sultan bows down with Helen Zinsmeister. El Sultan performs a stunt for Hi Sorrells in the late 1940s postcard below. (Above, courtesy of the Nash family; below, courtesy of Ray Manley Photography.)

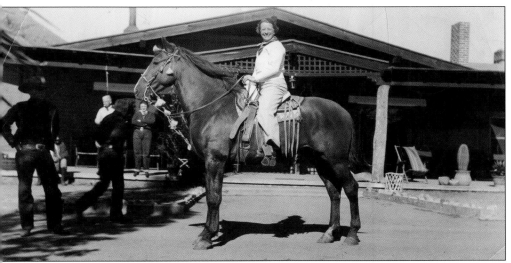

CIRCLE Z SECRETARIES. El Sultan had the distinction of being the only Spanish Carthusian stallion in the United States. He was truly the pride of Circle Z, especially to Lee and Helen Zinsmeister. The Spanish Carthusian was a magnificent horse to see and ride. At 17 hands tall, he had a gentle disposition and a remarkably smooth gait. He was so gentle that Circle Z staff and guests were allowed to ride him. El Sultan was loved and admired by all. Ranch employees were especially fond of him. Above, Lulu Virden, ranch secretary and hostess in the 1940s, sits tall in the saddle in front of the main ranch house. Below, El Sultan is ridden English style by Miss Snell, ranch secretary and hostess in the 1930s. (Both, courtesy of the Nash family.)

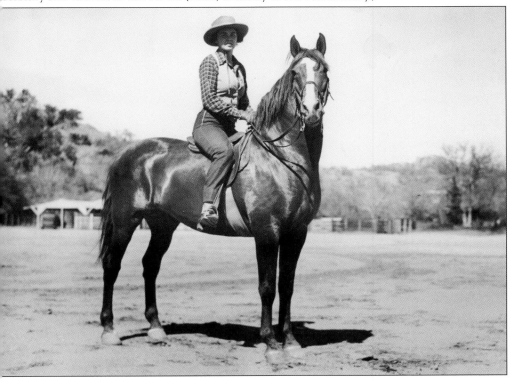

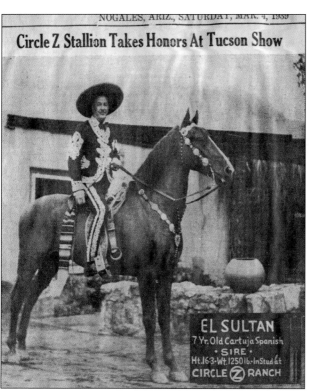

Circle Z Stallion Takes Honors At Tucson Show

EL SULTAN
7 Yr. Old Cartuja Spanish
• SIRE •
Ht.16·3-Wt.1250 lb.-In Stud at
CIRCLE ⓩ RANCH

SOUTHERN ARIZONA PARADES. In t
March 4, 1939, *Nogales International*
El Sultan and Lee Zinsmeister are
seen at left in full vaquero attire for
parade in Nogales, Arizona. Thoug
small in stature, Lee sits tall in El
Sultan's saddle. People in Patagonia
joked that El Sultan's Western
saddle, bridle, and breastplate had
more silver than Cortez took out
of Mexico. At the age of seven, El
Sultan received many awards at the
Tucson Rodeo horse show in 1939.
Lee Zinsmeister and El Sultan rode
in all the Nogales parades to the
delight of hundreds of spectators
who lined Morley Avenue. The
showman even trained a red parrot
to ride on his shoulder. El Sultan
was a regular entry at La Fiesta de
Los Vaqueros Parade in Tucson.
Pictured below in 1952 are Hi
Sorrells and El Sultan leading the
Circle Z contingent in the Tucson
Fiesta de Los Vaqueros Parade.
(Both, courtesy of the Nash family.

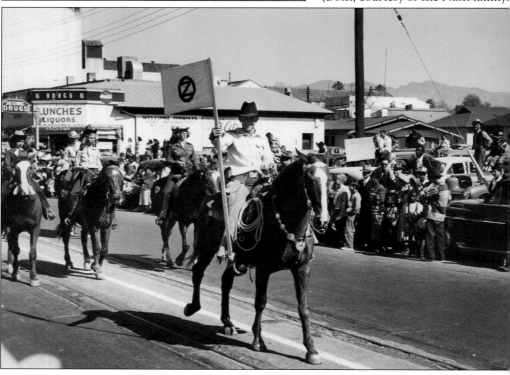

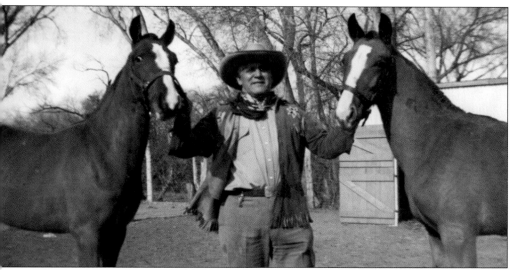

"POWDER RIVER JACK" LEE. "Powder River Jack" Lee was a popular entertainer touring the national rodeo circuit in the 1920s and 1930s. He and his wife, Kitty Lee, performed at rodeo halftime and fairground shows. They sang cowboy songs, recited cowboy poetry, and told colorful stories about the Wild West. Above, the entertainer poses with two colts El Sultan sired: Don Sancho (left), 11 months old, and Conchito (right), 10 months. Don Sancho took the blue ribbon in the class of 1938 foals, and a filly (not shown) placed fifth. For this entry, the two colts were shown with El Sultan to demonstrate his ability to reproduce his type. Each colt was much larger than the mare. Below, Powder River Jack tips his hat to the crowd as he parades El Sultan at the Fourth of July Patagonia Rodeo and Barbecue. (Above, courtesy of the Nash family; below, courtesy of the Bergier family.)

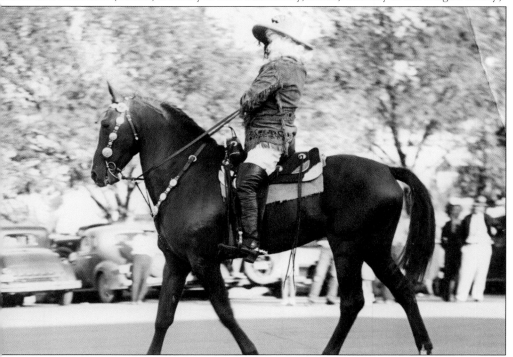

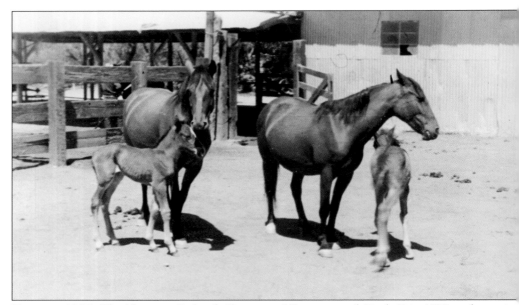

FOALS OF 1938. The Viscount Pedro de Domecq of Spain visited Circle Z in 1938 to determine if El Sultan was a Domecq stallion. To his knowledge, only three stallions had left Spain. When Lee Zinsmeister showed El Sultan and explained that the stallion had come from the stables in Havana, the viscount no longer had any doubt. The climate and location of the ranch was similar to the region where El Sultan was bred. Zinsmeister felt a cross of a better class of range mares would produce a larger breed of saddle horses that also would be good for cattle work. El Sultan sired over 30 foals at Circle Z. All had his gentle nature, smooth gait, and spirit. The photograph above shows a few Circle Z mares crossbred with El Sultan and their offspring. Below, El Sultan is executing a high jump. (Above, courtesy of the Nash family; below, courtesy of the Bergier family.)

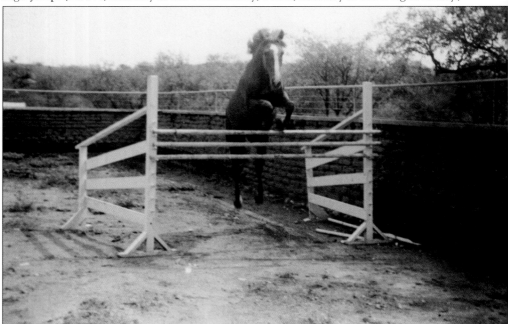

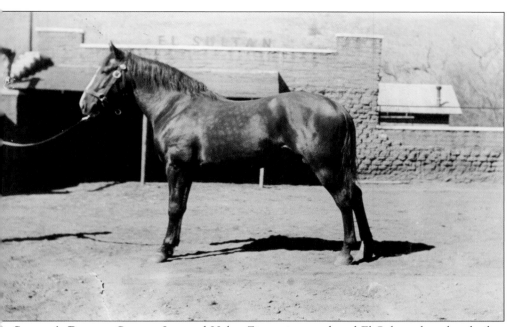

El Sultan's Private Stable. Lee and Helen Zinsmeister so loved El Sultan that they built a special adobe stable and corral for him. Below, local cowboy Don Farrell and El Sultan are pictured by the gate of El Sultan's stable. The walls of the stable were built two feet higher because of his height and ability to jump fences six feet high. Don A. Farrell worked on the Bird Yoas Ranch for four years before hiring on as Circle Z's ranch foreman in 1934. Farrell was an expert horseman and El Sultan's trainer for the next six years. He trained El Sultan to high jump, trick ride, and perform show riding in Western and English style. (Both, courtesy of the Nash family.)

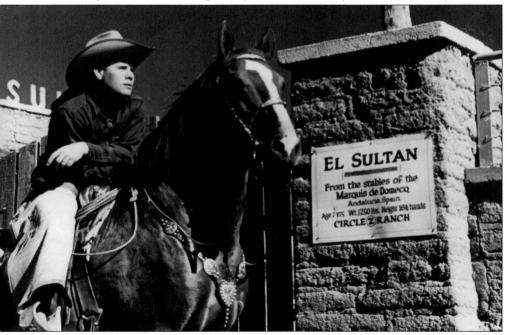

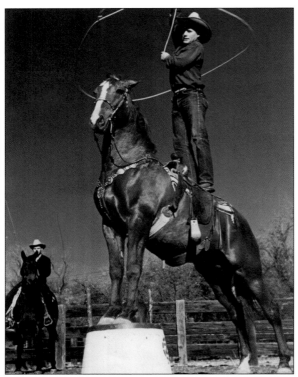

RODEO AND TRICK ROPING. To this day, Circle Z prides itself on its stable of gentle, well-bred horses, many of which were sired, foaled, and trained on the ranch. As regularly as possible, the cowboys from neighboring ranches were invited to Circle Z for a real bronc riding and roping rodeo. Circle Z guests were invited to the neighboring ranches to attend their round-ups and ride the range. Since El Sultan took well to cattle work, he was used at times for rodeo events and polo matches held at Circle Z. Don Farrell entertained guests performing trick roping stunts on El Sultan. (Both, courtesy of the Nash family.)

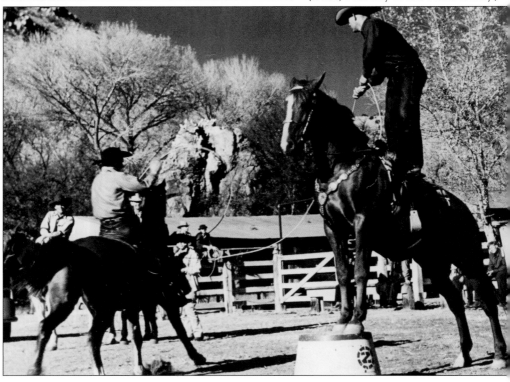

DON FARRELL AND HORSE SHOW PROGRAM. Don Farrell (pictured above with El Sultan) worked as the Zinsmeisters' wrangler, horse trainer, and ranch manager from 1934 until 1940, when he left to marry Edith Bergier and join the US Army. Staff Sergeant Farrell received an honorable discharge from the military in November 1945. He and his wife lived in the Patagonia area, where he worked as a horse trainer. In 1947, he was killed from a fall from his horse. He was training horses to rope calves at the Green Cattle Company Ranch in San Rafael Valley. He suffered a broken neck when thrown from the horse he was riding after the horse stepped on a calf. Farrell and El Sultan were featured on the cover of the 1941 Spring Horse Show program (right). Circle Z's El Sultan competed in the Road Hack, Other Recognized Breeds, Open Jumping, Ladies' Class, Trained Cowponies, and Dude Ranch Horse events. (Above, courtesy of the Nash family; right, courtesy of the Bergier family.)

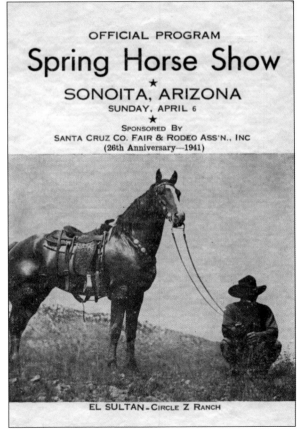

OFFICIAL PROGRAM
Spring Horse Show
★
SONOITA, ARIZONA
SUNDAY, APRIL 6
★
SPONSORED BY
SANTA CRUZ CO. FAIR & RODEO ASS'N., INC
(26th Anniversary—1941)

EL SULTAN - CIRCLE Z RANCH

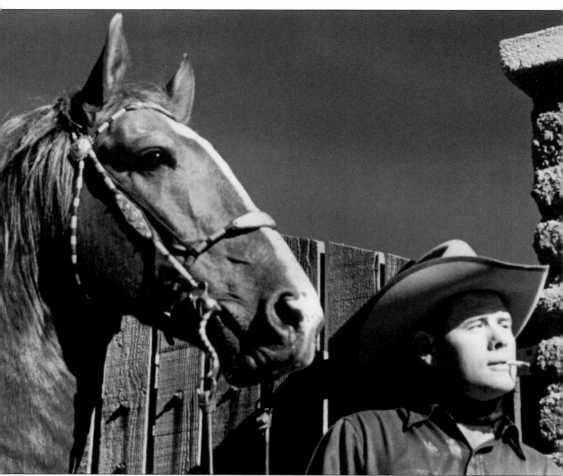

DON FARRELL AND EL SULTAN. When the Zinsmeister family sold the guest ranch, Helen Zinsmeister wrote in her letter to Charlotte Weaver that El Sultan was stabled at their ranch in Tombstone. In 1950, Helen returned the 18-and-a-half-year-old stallion to Wheaton and Isabel Allen, who had purchased the interest in Circle Z from Doug Robinson. The Spanish Carthusian continued to live at the ranch after Fred Fendig had purchased Circle Z. El Sultan was never to leave Circle Z again. In Lee Zinsmeister's words: "He was more than anyone could expect and a natural performer, jumper etc."—and was exercised daily even up to the time he died on January 2, 1953. Pictured here are Don A. Farrell and the renowned Spanish Carthusian stallion of Circle Z Guest Ranch. (Courtesy of the Nash family.)

Three

CHANGING HANDS

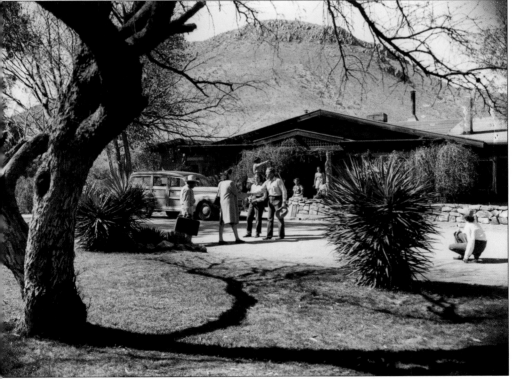

GUEST ARRIVAL. The Circle Z Guest Ranch changed ownership several times over the five years after Lee and Helen Zinsmeister sold the ranch to Douglas Robinson in 1946. Here, Circle Z guests are greeted with a warm welcome by friendly staff at the original main ranch house. They arrived by way of the Circle Z's Mercury Woody. (Courtesy of the Nash family.)

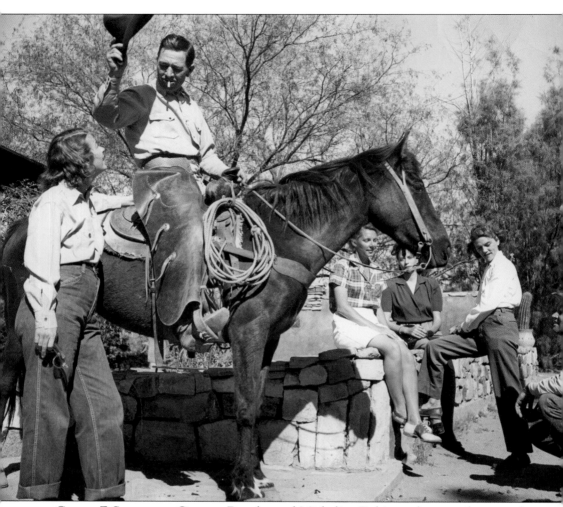

CIRCLE Z STAFF AND GUESTS. Douglas and Micheline Robinson became the second owners of the finest and best-known guest ranch in Arizona. Circle Z was the fourth guest ranch they owned in the Patagonia area, including the well-known Flying R Ranch. The Robinsons, who resided in Tucson, owned and managed Circle Z from 1946 to 1948. Douglas Robinson was from a prominent family. His father was secretary of the Navy from 1924 to 1929, and his mother was Franklin D. Roosevelt's first cousin. Robinson, a polio survivor like his mother, attended Evans School in Tucson. He graduated from Harvard in 1928 and returned to Tucson after World War II to open the Pacific Flying School, a private training program for Navy flight instructors. He sold the training center in 1943 to get into the dude ranching business. Circle Z staff and guests are pictured in front of the main ranch house in this photograph taken in 1946. (Courtesy of the Bergier family.)

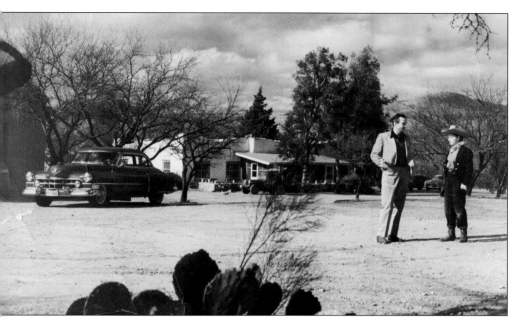

THE NEW MAIN LODGE. The *Tucson Daily Citizen* reported on November 22, 1946, that an accidental fire occurred at Circle Z headquarters. The main house was completely destroyed. Flames were first noted at midnight, and the cause was unknown. According to Douglas Robinson, there were no guests staying there at the time, as the building was being renovated. Persons at the scene worked to prevent the fire from spreading to the guest cottages grouped away from the building. The cost of damage was estimated at $40,000. The Zinsmeisters' sun-faded adobe residence became the central lodge. Three years after the fire consumed the main house, remnants of its existence still marked the site. Above, guest Fred Fendig converses with an unidentified guest near the main lodge in 1950. (Both, courtesy of Ray Manley Photography.)

SUN ROOM AND DINNER BELL. Owner Douglas Robinson estimated 25 to 30 winter guests woul[d] be received three weeks after the fire destroyed the original main ranch house. White-painte[d] stucco covered the Zinsmeisters' home. Lee Zinsmeister had landscaped the front yard with cact[us] and eucalyptus trees, embellishing the front of the building. The screened front porch enclose[d] the Sun Room (above), where guests enjoyed reading, relaxing, and playing cards. This was th[e] favorite spot where the children loved to play after dinner. In 1948, a large iron bell (below) wa[s] placed in front of the lodge. The bell, as in the past, is rung twice before each meal to call guest[s] to dinner. (Both, courtesy of the Bergier family.)

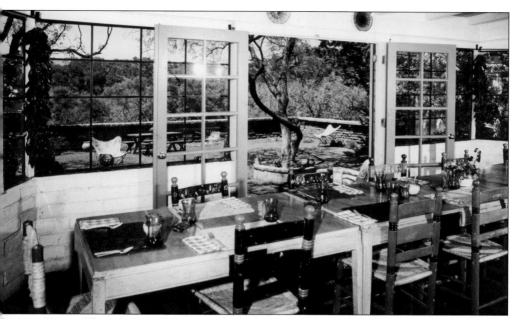

DINING ROOM. The interior of the main lodge had a lounge, two dining rooms, a kitchen, an office, and a bathroom. The lounge that looked into the second dining room had a massive stone fireplace and walls lined with reading materials and games. The dining rooms were furnished with colorful chairs and tables imported from Mexico. There was a dining room for guests and one for children who dined with the ranch staff. The dining area, seen above, was light and airy from the windows that looked out onto the walled patio garden and lush green lawn. (Courtesy of Ray Manley Photography.)

MAIL DELIVERY PLANE. The outdoor patio was a delightful spot for guests to relax in the sun, write letters, or read mail. The Nature Conservancy adjacent to the north end of the ranch was developed in the late 1960s. Many species of birds are frequent visitors to the bird feeders on the patio. This c. 1946 photograph shows a private mail delivery service that picked up and delivered mail to Circle Z. (Courtesy of the Nash family.)

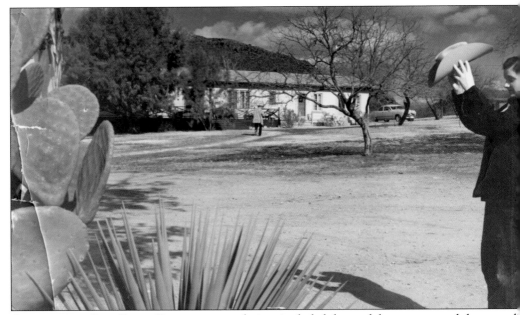

CANTINA AND CASA ROSA. Guest accommodations included three adobe cottages and three small wood-framed houses. The cottages could accommodate two to four people. The larger ones could house up to eight. James Robb of Tucson was the ranch manager. He, his wife, and their four children lived in the small house near the guest cottages. Pictured above is the house known as the "Cantina" (canteen). This is the place where guests would go to socialize and have a drink at the bar before dinner. The Casa Rosa, with eight rooms, was the largest and most appealing guest cottage from the Zinsmeister era. The wide closets in the bedrooms were designed to store large train suitcases. Most of the cottages were made of adobe and painted pink with a green roof. Two housekeepers from Patagonia cleaned the cottages every day. (Both, courtesy of Ray Manley Photography.)

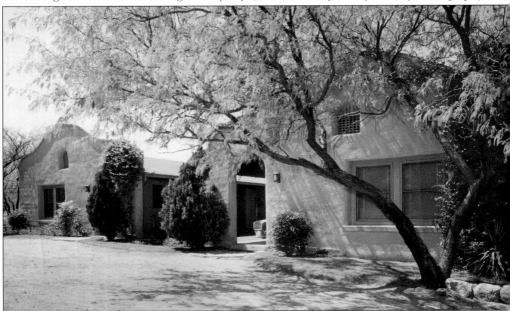

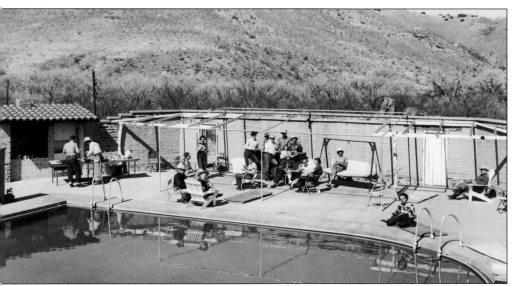

SWIMMING POOL AND PATIO. Twelve-year-old Carol E. Sanford, her father, and her younger sister, Sue, were first-time guests at the ranch during the final winter season (1947–1948) of Robinson ownership. Carol provided a detailed description of her experience in a report titled "Memories of the Circle Z Ranch." "Tiny" Munns was the guest hostess. Marjorie Palmer and Jean Hewitt were the ranch secretaries and assistant hostesses. James Robb was the ranch manager at the time. Hewitt gave Sue a medal for pulling Wickie, Robb's son, out of the swimming pool. Shown here is the swimming pool, near where the main ranch house once stood. By 1947, the original concrete-lined swimming pool by Sonoita Creek was no longer in use. Here, guests relax around the swimming pool after a buffet dinner in 1950. (Courtesy of the Nash family.)

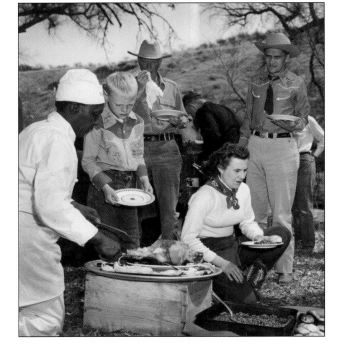

COWBOY COOKOUT PICNIC. The all-day cowboy cookout trail ride to Twin Peaks and other canyons in the Patagonia Mountains was a guest favorite. Shown is Circle Z cook Willie Barnes serving up beef, beans, and biscuits. Ranch staff would take non-riding guests to meet the riders at the cookout location. (Courtesy of Ray Manley Photography.)

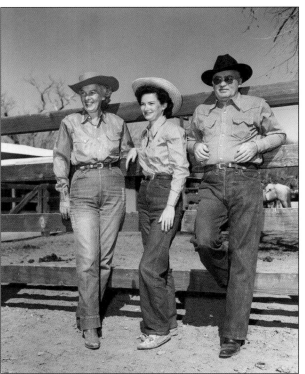

THE LOCKRAE FAMILY. The Robinsons sent formal invitations to the Zinsmeisters' guests to encourage them to return. The announcement stated: "Mr. and Mrs. Douglas Robinson take great pleasure in announcing the purchase of Circle Z Guest Ranch, Patagonia, Arizona from Mr. and Mrs. Zinsmeister and look forward to the opportunity of meeting and entertaining former guests of Circle Z." Lulu Virden, the Zinsmeisters' ranch secretary and hostess, took a job with the famous Monte Vista Resort in Wickenburg. The Weaver family followed her there. Posing at the corral are, from left to right, Ruth Lockrae, Anne Lockrae, and A.H. Lockrae, vice president of Minneapolis's Honeywell Company. The family vacationed at the ranch for over 30 consecutive seasons beginning in 1936. Anne later married Patagonia business owner Gray Steele. (Courtesy of Ray Manley Photography.)

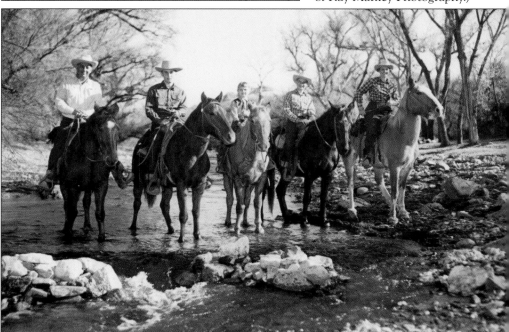

THE MASTERS FAMILY. Doree Masters (center) poses with her parents and siblings on a horseback ride to Sonoita Creek. This c. 1950 photograph was taken by Ray Manley. (Courtesy of Ray Manley Photography.)

NEW GUEST FAMILIES. In the late 1940s, the ranch attracted families with young children, as pictured above. Youngster Carol Sanford wrote about activities she enjoyed as a guest in 1948, such as branding, earmarking cows, calf roping, the Kinsley Ranch Rodeo, and the Sonoita Quarter Horse Show & Races. Ever since the American quarter horse show began in 1939, local ranches competed to see whose quarter horse was the fastest or the best working ranch horse. Blaine Lewis, local horse breeder and former Circle Z wrangler, showed an impressive stallion named Texas Bee, who won many of the prizes at the show Carol attended. Below, a young guest is practicing roping in the ranch corral. (Both, courtesy of the Nash family.)

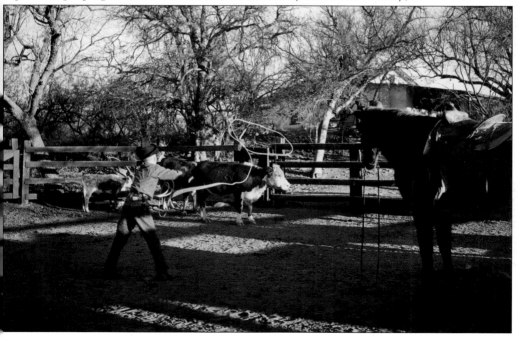

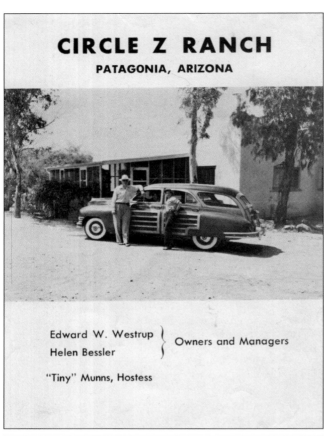

CIRCLE Z RANCH

PATAGONIA, ARIZONA

Edward W. Westrup ⎫
Helen Bessler ⎭ Owners and Managers

"Tiny" Munns, Hostess

GUEST BOOKLET, 1948–1950. Edward W. Westrup and Helen Bessler became part owners and managers of Circle Z in 1948. They purchased the ranch from Douglas Robinson for $150,000. Westrup and Bessler were from Chicago before making their home in Tucson. Helen Bessler was a certified public accountant and former editor of the *Commerce Clearing House* publication. Ed Westrup was in the real estate business for 25 years. August 15 marked the grand opening of the guest ranch under the new owners and managers. On the cover of the guest booklet for the 1948–1949 season, Ed Westrup, Helen Bessler (front seat), and "Tiny" Munns strike a pose in front of the main lodge. The Sun Room is in the background. Room rates per week included a horse and meals prepared by a well-known chef from Chicago. (Both, courtesy of the Nash family.)

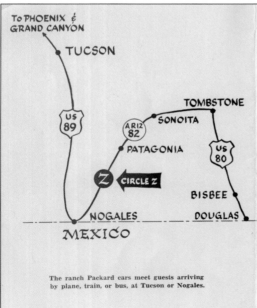

To PHOENIX & GRAND CANYON
TUCSON
US 89
ARIZ 82 SONOITA TOMBSTONE
PATAGONIA US 80
CIRCLE Z
BISBEE
NOGALES DOUGLAS
MEXICO

The ranch Packard cars meet guests arriving by plane, train, or bus, at Tucson or Nogales.

SCHEDULE OF RATES
For 1948-49 Season

RATES IN EFFECT JAN. 1 TO JAN. 14 AND
APRIL 16 TO DEC. 31

Weekly charge including meals, and horse
for each guest

	Each
Single, private bath	$96.00
Single, connecting bath	72.00
Double, private bath, twin beds	70.00
Double, connecting bath, twin beds	60.00

Children under 12 years, 15% less if occupying room with connecting bath.

RATES IN EFFECT JAN. 15 TO APRIL 15

Weekly charge including meals and horse
for each guest

Single, private bath	$120.00
Single, connecting bath	90.00
Double, private bath, twin beds	87.50
Double, connecting bath, twin beds	75.00

No reduction for children during this season.

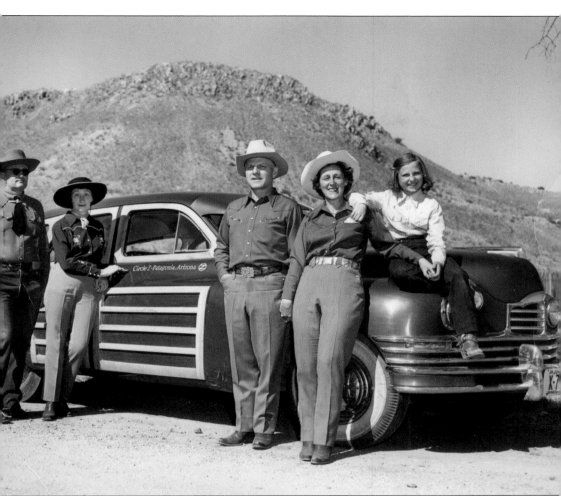

WESTRUP, BESSLER, AND ALLEN FAMILY. Charles Wheaton Allen and Isabel A. Allen of Elmhurst, Illinois, bought an interest in the ranch. Deciding factors for the Allens to run a year-round guest ranch included the ideal surroundings of the 2,800-acre ranch, the delightful summer climate, and the short drive from Tucson. By December 1950, Bessler and Westrup sold all their interest to the Allens. Bessler and Westrup, however, continued to be active in the management of the ranch. According to a reporter from the *Chicago Tribune*, "In fact, the Allens are pushing the idea of a year-round guest ranch, having found that the many Tucsonians like to come up to the Circle Z's 4,000 foot elevation during hot weather." In January 1951, the *Tucson Citizen* reported that Bessler purchased the Barber Ranch, located near downtown Tucson. In this 1949 photograph are, from left to right, Edward Westrup, Helen Bessler, Wheaton Allen, Isabel Allen, and daughter Cheryl W. Allen. (Courtesy of Ray Manley Photography.)

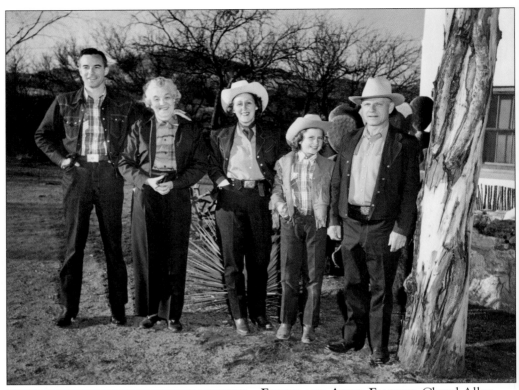

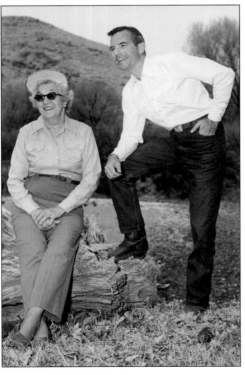

FENDIG AND ALLEN FAMILIES. Cheryl Allen attended Patagonia Grammar School with Walter Kolbe's sons, Walter Jr., John, and Jim. The youngest son, Jim Kolbe, later represented southern Arizona in the US House of Representative for 22 years. The Kolbe family, formerly of Winnetka, Illinois, purchased the Rail X Ranch in Patagonia after having vacationed at the Circle Z Ranch. The Rail X, Empire, Arivaca, and Eureka Ranches had been purchased by the Boice family of the Chiricahua Ranches Company to extend their range holdings in southern Arizona between 1924 and 1928. In February 1950, Chicago banker Fred Fendig took a vacation to the Circle Z Guest Ranch. Lella Fendig, his doting mother, and friends William and Ruth Crawford and their daughters, Barbara and Cecie, accompanied him. Photographer Ray Manley was there at the same time to do photo shoots for *Arizona Highways*. Pictured above are, from left to right, Fred Fendig, Lella Fendig, Isabel Allen, Cheryl Allen, and Wheaton Allen. At left, Fred Fendig poses with Lella Fendig near the banks of Sonoita Creek. (Both, courtesy of Ray Manley Photography.)

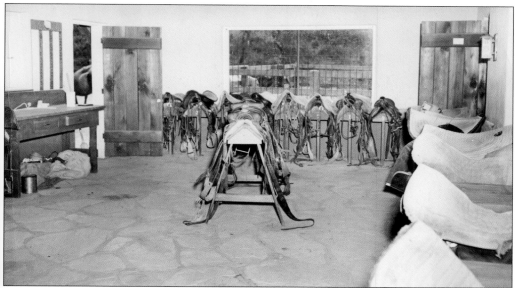

SADDLE ROOM AND CORRAL. A large barn with tack room, hay room, and feed room overlooks the corral. Attached to the barn is a roof with feed rack. Behind the barn is the larger, usually open corral by Sonoita Creek. All the horses are let out at night in the hills to graze. The saddle room (above) with shaded porch was adjacent to the horse corrals. It was complete with picture windows, flagstone floor, and a social corner with a fireplace. This area soon became a favorite place for the riders to gather. On the corral fence (far left) in the 1950 photograph below are, from left to right, Helen Bessler, Tiny Munns, and Wheaton Allen. Some of the riders pictured are, from left to right, (first row) Lella Fendig, Bernice Key, Cheryl Allen, and wrangler John Cameron; (second row) Pat Smith, Fritz Smith, Bunny Sortor, and wrangler Hi Sorrells; (third row) Mary Baker, Ruth Lockrae, Isabel Allen, and Hal Sortor. (Both, courtesy of Ray Manley Photography.)

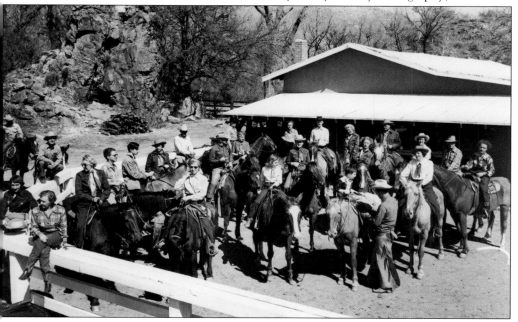

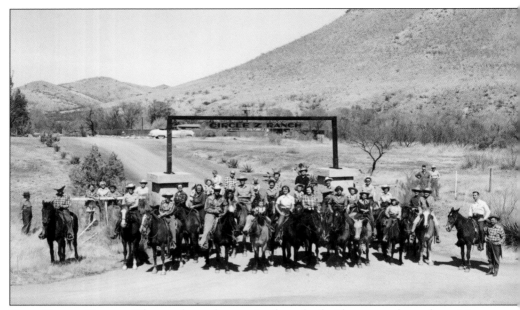

TRAIL RIDING PARTIES. The regular early-morning horseback ride was two hours long. Most guests were experienced in English riding but not Western saddle riding. The wranglers divided trail parties into small groups based on their riding experience. Above, guests and the Allen family pose in front of the Circle Z entrance. From left to right are (first row) wrangler John Cameron (fourth) and Fred Fendig (far right); (second row) Ruth Crawford (second) and Isabel Allen (far right). Lella Fendig is standing behind the fence at far left. A 1949 or 1950 Buick convertible is seen in the background. Below, a moderately experienced riding party led by wranglers Vince Farley (far left) and John Cameron (far right) is loping through Sonoita Creek. (Both, courtesy of Ray Manley Photography.)

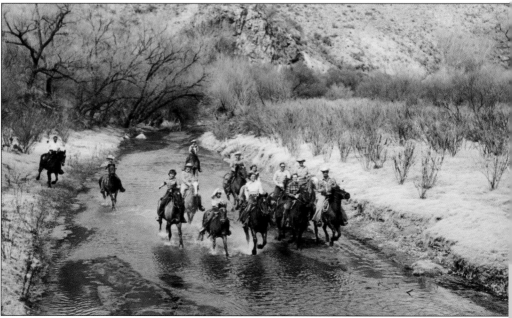

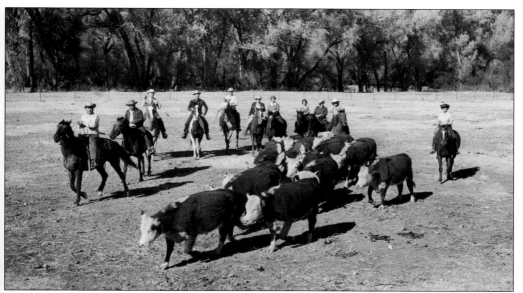

GUESTS AS RANCH HANDS. Grover Kane was the manager before Jim Robb hired on with Douglas Robinson. Head wrangler Dick Barkley and wranglers Vince Farley and Bobo Chapman worked at the Circle Z for Kane and Robb. Local cowboys Harvey Whelan, Wilford Whelan, Fred Acevedo, Vince Farley, Hi Sorrells, and John Cameron were the Circle Z ranch hands and wranglers from 1948 through 1950. The photograph above captures guests being "extra hands" for cowboy-wranglers Harvey Whelan (far left) and Henry Acevedo (second from left) as they move calves from the pasture. Below are guests helping Harvey Whelan (left) and Fred Acevedo (right), round up the horses. Harvey Whelan left Circle Z about 1950 to be the ranch foreman for the newly built Weatherhead Ranch, owned by industrialist Albert J. Weatherhead III of Cleveland, Ohio, and the former guest of Lee and Helen Zinsmeister. (Both, courtesy of Ray Manley Photography.)

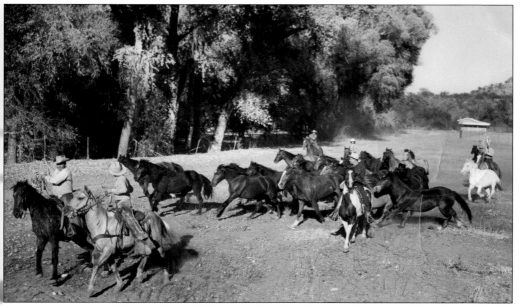

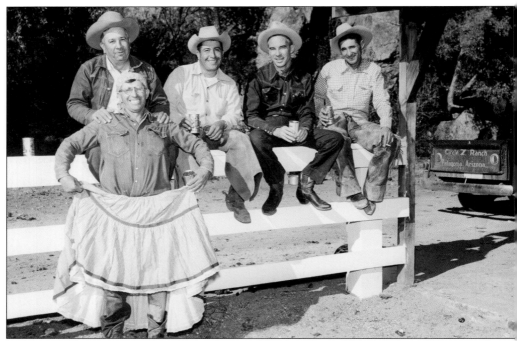

PATAGONIA RANCHING FAMILIES. Members of the Whelan and Acevedo families worked at Circle Z during and after World War II. As a teen, Wilford Whelan worked for the Empire Ranch with his uncle as the chuck wagon chore boy. Whelan settled in Patagonia to work in the mines because he was over the age to enlist in the US Army, as his son Harvey did. After the war and graduating from Yuma High School, Margaret Whelan moved to Patagonia to work with her father at Circle Z. Above, Wilford Whelan jokes around with, from left to right, Henry Acevedo, Harvey Whelan, Fred Fendig, and Fred Acevedo. Below, Lella Fendig (first row, far left), Fred Fendig (far right), Margaret Whelan Salge (second row, center) and guests pose before a branding demonstration. (Both, courtesy of Ray Manley Photography.)

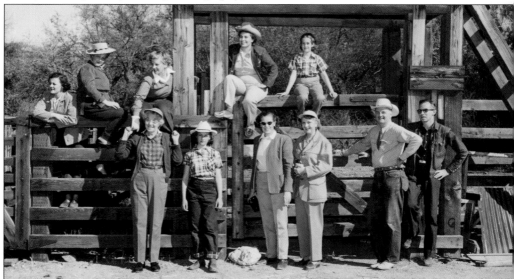

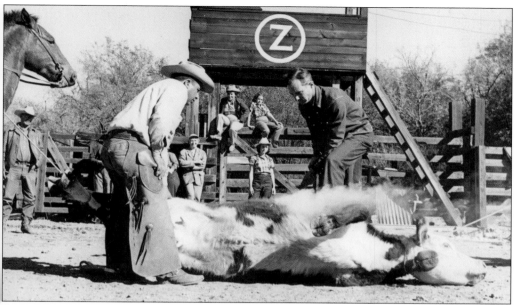

GUESTS BRANDING. The Zinsmeisters employed Margaret Whelan as a cook and then as the caretaker for their son Bill. First, she lived in a small room at the bunkhouse. Later, she moved into a small house near the Zinsmiesters' residence. She met her husband, Roy Salge, at a dance in Patagonia. Roy Salge was an expert leather craftsman, saddle maker, and the business partner of silversmith Paul Showalter. In the 1950s photograph above, Margaret Whelan Salge and guests watch as Fred Fendig tries his hand at branding under the supervision of her brother, Harvey Whelan. Soon after, Margaret Salge and Wilford Whelan followed Harvey Whelan to the Weatherhead Ranch, known today as the IJ Bar Ranch. Margaret Salge worked for the Weatherhead Ranch for the next 50 years. Below, from left to right, Henry Acevedo, Roy Salge, Harvey Whelan, an unidentified guest, and Fred Acevedo brand a cow in the corral. (Both, courtesy of Ray Manley Photography.)

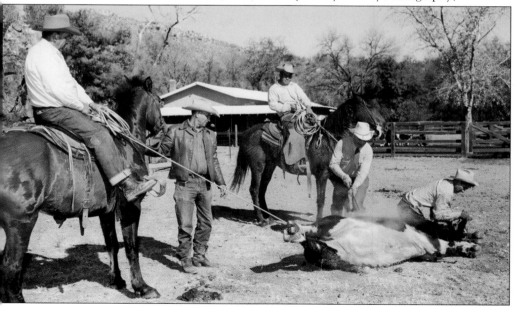

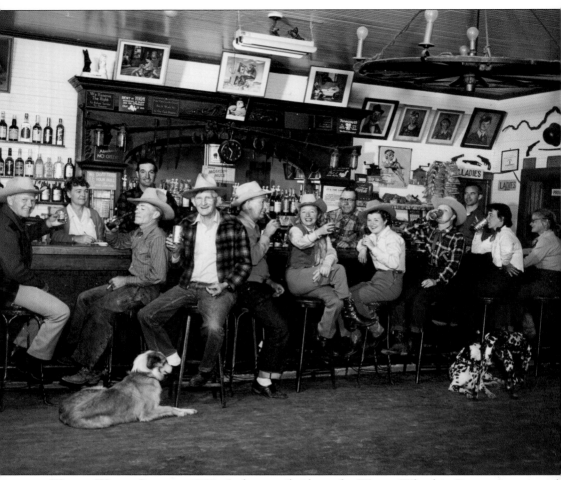

WAGON WHEEL SALOON, 1950. A short trail ride to the Wagon Wheel in Patagonia was, and continues to be, a favorite for Circle Z guests. Michael Cervantes, grandson of Hugh Schumake, spent school vacations with his grandparents in Patagonia. Years later, he tended bar for them at the saloon. The bar was originally from the ghost town of Charleston, between Tombstone and Sierra Vista, Arizona. The year "1882" is engraved in the wood on the back. Cervantes said, "I was told that when they moved it from this old bar [across from the train depot] down to the new location, it took over four piano dollies because that thing weighs well over three tons and it took quite a few people to move it." Sitting at the bar are the dudes who rode into town, including Vince Farley (second from left), Bunny Sortor (second from right), and Ruth Crawford (far right). Behind the bar from left to right are "Ma" Schumake, John Cameron, Hugh Schumake, and Fred Fendig. (Courtesy of Ray Manley Photography.)

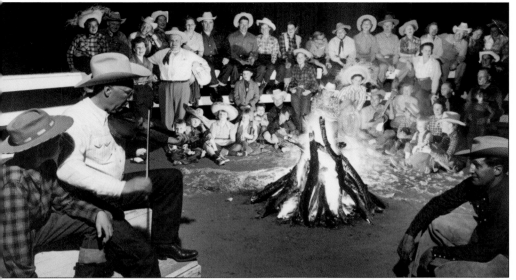

CAMPFIRE SING-A-LONG. Ranch staff arranged entertainment for the amusement of their guests in the evening after the dinner meal. Often, the wranglers accompanied guests on day outings off site and other planned diversions at the ranch. Although children ate meals in a separate dining room from the adults, they were included with all the guests for trail rides and other diversions. Pictured above is a local musician playing fiddle while guests enjoy singing around the campfire. Wranglers John Cameron (front, far right) and Vince Farley (mid-ground, to right of Cameron) are enjoying the warmth of the fire, music, and the friendships they made with their guests. Pictured below are the younger guests taking delight in the toasting of marshmallows. (Both, courtesy of Ray Manley Photography.)

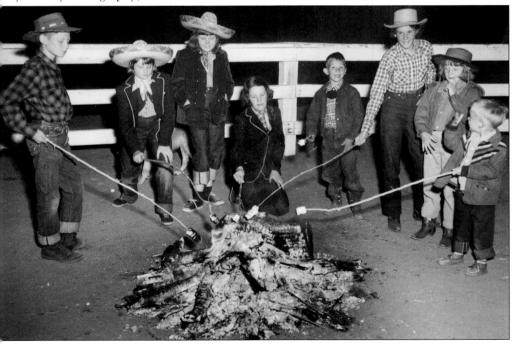

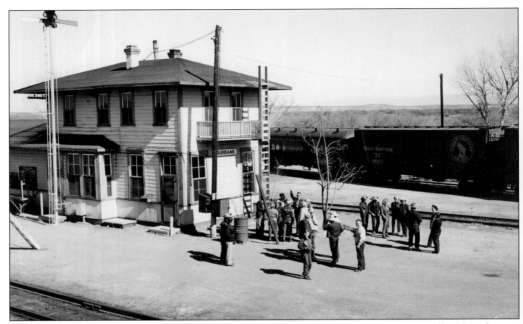

SIGHTSEEING TRIP. These 1950 photographs were taken of guests visiting the small railroad town of Fairbank, located eight miles west of Tombstone and 50 miles from Circle Z. Fairbank was an important depot established with the coming of the railroad in 1881. The town was named in 1883 in honor of N.K. Fairbank of Chicago, who helped finance the railroad. The New Mexico & Arizona Railroad train car is stopped at the Fairbank depot. Below, guests are shown at Fairbank's mercantile. Among those pictured are Bunny Sortor, Isabel Allen, Lella Fendig, Ruth Crawford, Vince Farley, Fred Fendig, Wheaton Allen, and John Cameron. (Both, courtesy of Ray Manley Photography.)

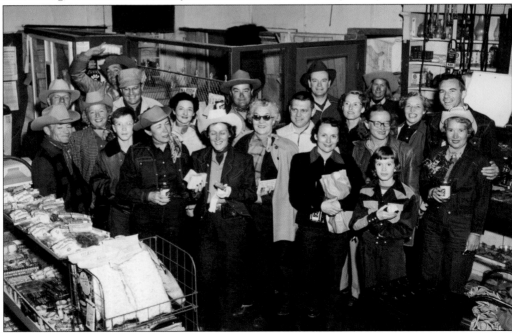

Four

NOT JUST A RANCH
BUT A WAY OF LIFE

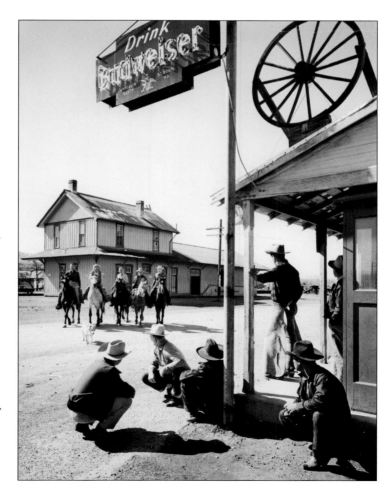

TOWN CHARACTERS.
Arizona Highways
featured this 1952 Ray
Manley photograph
titled "Town
Characters." The photo
shoot took place in the
main street of Patagonia.
The "characters" are
dudes and wranglers
from Circle Z Ranch.
The riders, from left to
right, are Fred Fendig,
Ruth Peterson, Mary
Baker, Vince Farley, and
an unidentified guest.
John Cameron (far left)
stands on the porch
of the Wagon Wheel
Saloon with other locals.
In the background
is the landmark
Patagonia Train Depot.
(Courtesy of Ray
Manley Photography.)

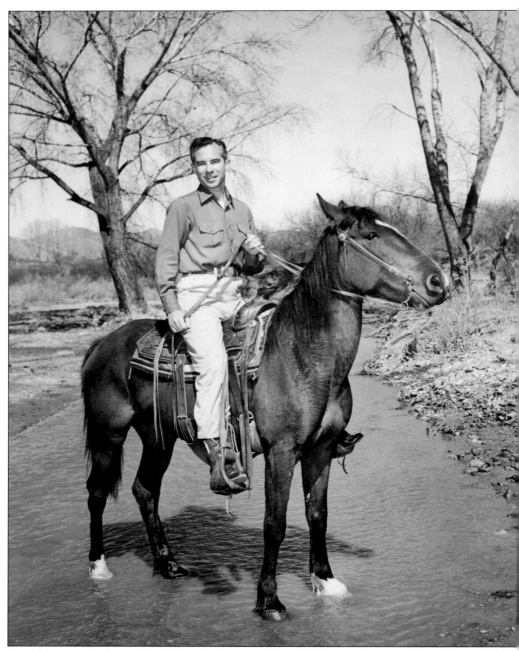

FRED FENDIG. Frederick "Fred" Fendig, born on May 4, 1911, was the son of Fredrick and Lella Fendig of Rensselaer, Indiana. The Fendig family owned extensive property in the Rensselaer area. At 39 years old, Fendig was a successful banking executive at the Harris Trust Company in Chicago. Wearing Western clothes, horseback riding, playing cowboy, and relaxing at the Circle Z Guest Ranch unexpectedly changed Fred's mind about his career and life's ambition. Fred Fendig had no intention of going into the cattle ranching and hotel resort business once he returned to Chicago. Here, he poses in Sonoita Creek. (Courtesy of Ray Manley Photography.)

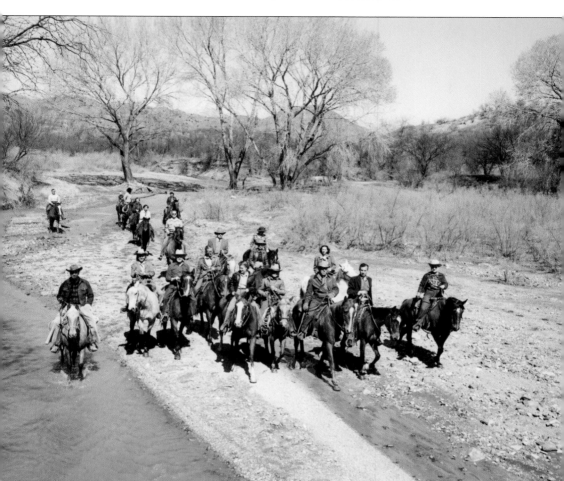

SONOITA CREEK TRAIL RIDE. When Fred Fendig learned that Circle Z Guest Ranch in Patagonia was back up for sale, he decided to buy it with the help of Lella Fendig, other relatives, and his friends William and Ruth Crawford. His family was surprised by his impulsive decision to leave banking, start a new business venture that he knew nothing about, and leave the Windy City for a small, rural community in Arizona. This photograph, taken about the time Fred Fendig purchased the Circle Z Ranch in 1951, shows Fendig leading a trail party along the banks of Sonoita Creek. Pictured in the first row are, from left to right, John Cameron, Ruth Peterson, Vince Farley, an unidentified guest, Fred Fendig, and an unidentified guest. The Circle Z Mountain is seen in the distance behind the giant cottonwoods. (Courtesy of Ray Manley Photography.)

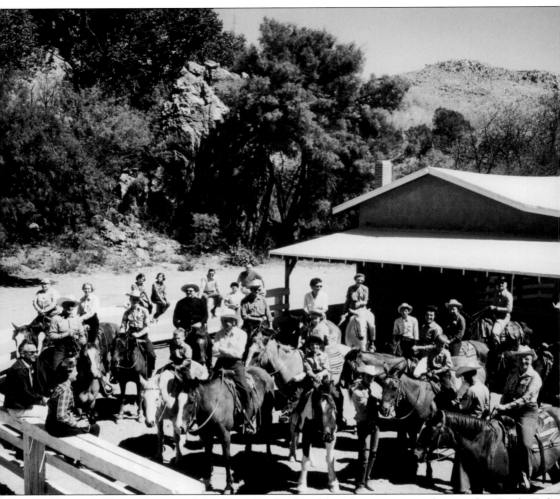

FENDIG'S DUDE RANCH. After Fred Fendig lived his dream as a cowboy at the Circle Z, he purchased the controlling interest of the ranch from Charles W. and Isabel Allen in August 1951 for about $150,000. The Allen family moved to California immediately following the sale of the guest ranch. Fendig assumed sole ownership and active management of the property. At the time of purchase, the ranch headquarters plus property covered 2,800 acres of land and included a string of 70 horses. Many of the remaining horses were from the bloodline of El Sultan. Shown is Fred Fendig (foreground, left) sitting on the corral fence before the daily trail ride. (Courtesy of Ray Manley Photography.)

FRED AND MAJOR. Six-foot-tall Fred Fendig was a confirmed bachelor. Here he is pictured in front of the main lodge with his dog, Major. The story goes that Fendig named the dog Major because his neighbor Ray Bergier of the Hard Luck Ranch had a dog named Sergeant. (Courtesy of Ray Manley Photography.)

FENDIG RESIDENCE. Fred Fendig was determined to continue running Circle Z as both a guest ranch and a working cattle ranch operation. He announced that the grand opening was planned for mid-September. He spent the summer of 1952 at the H Bar Ranch in Saddlestring, Wyoming. He visited other guest ranches in Wyoming and Colorado before returning to Circle Z. The Cantina was complete with a no-host bar, flagstone fireplace, and one bathroom. Its wide porches were comfortably furnished. This was the perfect place for guests to relax and watch the sunset. Marjorie Palmer and Jean Hewitt, ranch secretaries and hostesses for former owner Douglas Robinson, had lived in the small back room of the Cantina. Fendig made the back room his living quarters. The main room of the Cantina is shown below. (Above, courtesy of Ray Manley Photography; below, courtesy of the Bergier family.)

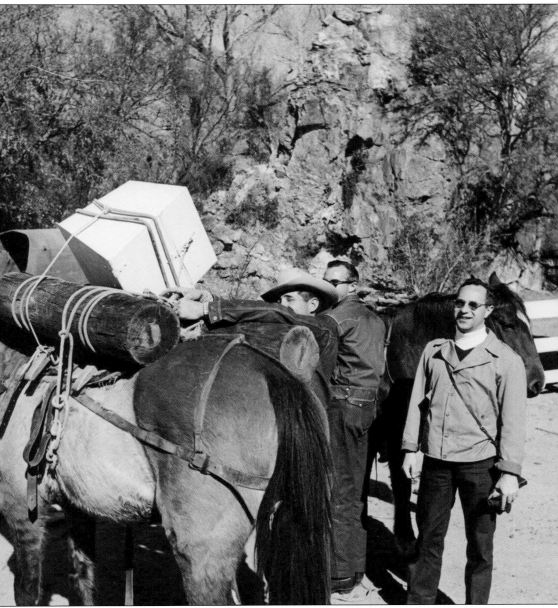

BILL CRAWFORD AND FRED FENDIG. In 1951, William F. Crawford and Fred Fendig purchased an American Hereford bull (sire Majestic Domino) from Walter Wagner of Lazy J2 Ranch in Patagonia for $450. One year later, Crawford and Fendig became partners in the cattle breeding business. The terms of the three-year agreement, beginning on March 30, 1952, and ending on May 31, 1955, stipulated that Circle Z Ranch Inc. would pasture, feed, and care for on Circle Z property and pay all costs incurred for not more than 42 head (40 cows and 2 bulls) and their offspring belonging to Crawford. The two would split the calf crop. In this 1952 photograph, John Cameron (left), Fred Fendig (center), and Bill Crawford (right) are shown in the corral. (Courtesy of Ray Manley Photography.)

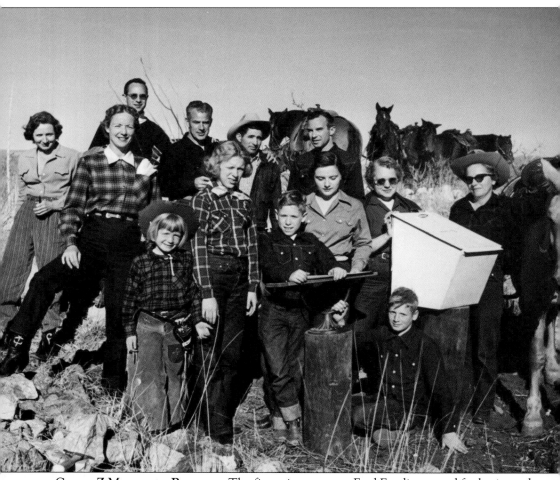

CIRCLE Z MOUNTAIN REGISTER. The first winter season Fred Fendig opened for business, he and a riding party of 13 friends and relatives placed a metal box at the top of Circle Z Mountain. In the box he left a record book, pencil, and buttons. On December 30, 1952, he wrote the following message: "You've had it! Now you're on the top, and you're feeling mighty low, so take a peek around you and see what's down below. Now have a look inside this book and see who's been before ye. Sign! You're in the inner circle (z) of this rare fraternity. Then reach into the old tin box and take your button (Free!) Pin it on—and bring it down and have a coke on me." Many horseback riders and hikers have ventured to the top of Circle Z Mountain to sign the register and leave funny comments and sketches. In the back row are, from left to right, Ruth Crawford, Bill Crawford, Ted Beach, an unidentified wrangler, and Fred Fendig (far right). (Courtesy of Ray Manley Photography.)

PANORAMIC VIEW OF CIRCLE Z. Taken from atop Circle Z Mountain looking southwest, this image shows a panoramic view of the Circle Z Ranch complex. The ranch is tucked between the Santa Rita Mountains to the north, the Patagonia Mountains to the east, the Santa Cruz Valley to the west, and Mexico to the south. In the 1940s, Arizona State Highway 82 was cut into the mountains adjacent to the ranch. Indian artifacts may still be found on Circle Z Mountain and along the creek below. Some Patagonians call the mountain "Elephant Mountain" because it looks like the side view of an elephant when driving down the highway from Nogales to Patagonia. Here, Fendig's cousin Ted Beach and an unidentified boy take in the view from the overlook. (Courtesy of Ray Manley Photography.)

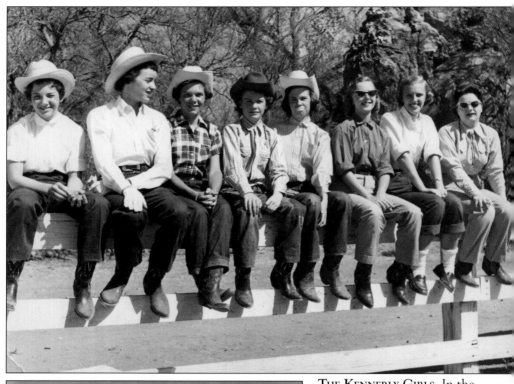

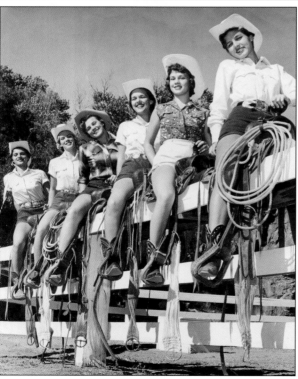

THE KENNERLY GIRLS. In the summer of 1952, Circle Z was used to house a group of teenage girls from the Kennerly Ranch Finishing School. Mrs. T. Everton Kennerly and the young women traveled from Houston, Texas, to participate in the six-week training course she developed to provide instruction and opportunity for them to learn to cook, sew, and keep house. The girls were required to keep their rooms clean, take turns with kitchen duties cook meals, and sew an ensemble. They took advantage of the Circle Z horseback riding experience and other diversions as well. The ranch attracted national attention as a unique opportunity for girls. They returned the following summer. The photograph above was taken of the girls upon their arrival at Circle Z. The image at left shows them taking time off from training. (Above, courtesy of the Bergier family; left, courtesy of the Nash family.)

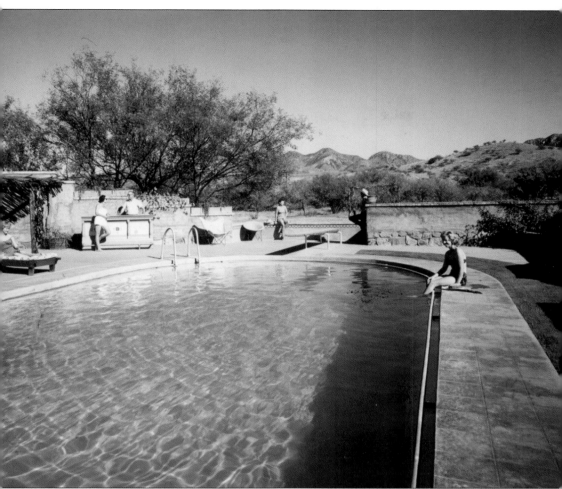

SWIMMING POOL AND PATIO. After a long day in the saddle, some guests liked to take a dip in the heated swimming pool before going back to their rooms to get ready for the 7:00 dinner hour. The swimming pool, seen here in 1970, is hidden from the tennis courts by a stone wall. The pool is four to eight feet deep with two ladders and a diving board. On one side of the pool is the Mexican-style patio with tables, lounge chairs, and barbecue grill. A small bathhouse is located on each side. Fred Fendig's Circle Z Guest Ranch brochure stated, "For your added pleasure a filtered swimming pool, tennis, shuffleboard, croquet, badminton, trap-shooting and horseshoe courts. We provide a cantina, rodeo field tack room, secluded nooks for sunbathing, good books . . . and of course *Horses of the Great Out-of-Doors!* The Audubon Sanctuary on our property is nationally famous for its profusion and variety of birds." (Courtesy of Ray Manley Photography.)

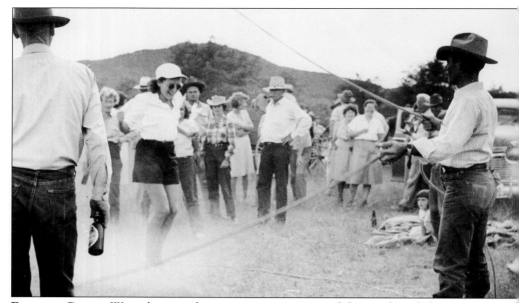

FUN AND GAMES. Wranglers are always an important part of the ranch and the guests' overall vacation experience. Besides working to care for the horses and cattle and leading guests on unforgettable horseback riding adventures, they volunteered their free time to join the guests in the scheduled ranch activities. They always welcomed guests to be extra hands in the ranch hand traditions. Guests could ride and work right along with the cowboys to help brand calves, run cattle, and check fence lines. Some regular guests established friendships with others. Some of the returning families scheduled their vacations at the same time each year. Circle Z Ranch was a special place for them, where they could continue their friendships and enjoy watching their children grow up together. In these 1970s photographs, several families gather on Easter Sunday. (Both, courtesy of the Nash family.)

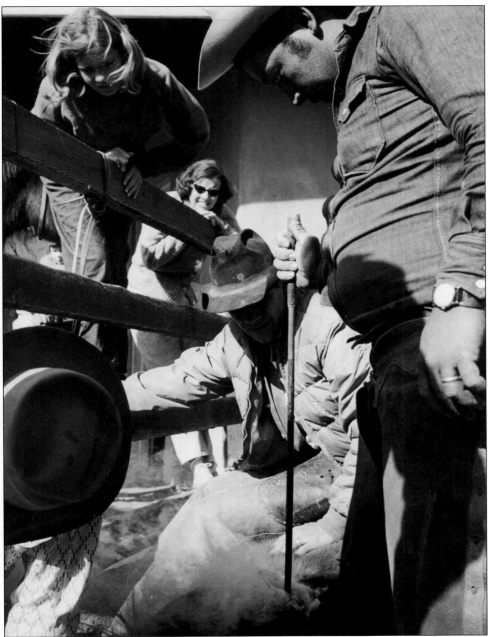

FENDIG'S RANCH MANAGERS. Alejandro "Cano" Quiroga was Fred Fendig's ranch foreman from 1960 to 1969. Quiroga's youngest brother, Gilbert, loved horses and always wanted to cowboy like his brother. Cano brought Gilbert and brother-in-law Ralph Padilla to ride for the ranch and help round up the horses for the guests before taking them to school in his truck. Gilbert became a part-time cowboy-wrangler on the weekends. In this 1963 Ray Manley photograph, Cano Quiroga (right) brands a horse with the help of John Kuhn (left), and Gilbert Quiroga (center). Movie director Orsla Semus (sunglasses) and daughter watch with curiosity. Semus was on location at the ranch to film a movie for Swedish Airlines Systems. (Courtesy of Gilbert Quiroga.)

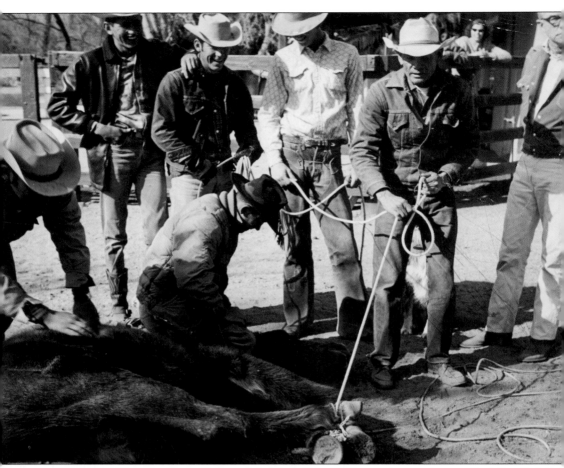

BRANDING HORSES. Cano Quiroga left Circle Z in 1969 to train race horses. Fred Fendig hired Gilbert Quiroga as the ranch manager for $300 per month. Quiroga and his wife, Peggy, lived and worked on the ranch for the next five years. Pictured in this Ray Manley photograph are from left to right, (front row) unidentified cowboy, Gilbert Quiroga, (second row) Ralph Padilla, Bob Quiroga, John Kuhn, Manuel Salazar, and Fred Fendig. In the background at far left, Orsla Semus observes the action from behind the corral fence. (Courtesy of Gilbert Quiroga.)

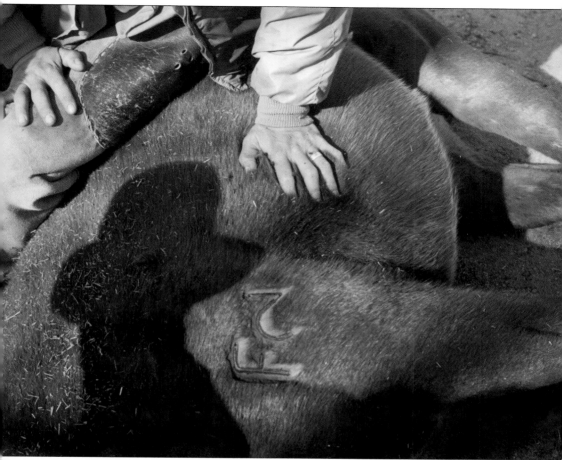

THE FENDIG BRAND. Branding is a technique for permanently marking large livestock to identify the owner. Each brand is by necessity different from others and often reflects the personality of the owner. Traditional hot brands, alternative freeze brands, and the location where the brand is placed are recorded and published by state livestock agencies. Bill Crawford's brand was "C4" for the first initial of his last name and the four members of his family. Shown in this 1963 Ray Manley photograph is Fred Fendig's "F Lazy 2" brand used to identify his horses. The brand stands for the two initials of his first and last name. (Courtesy of Gilbert Quiroga.)

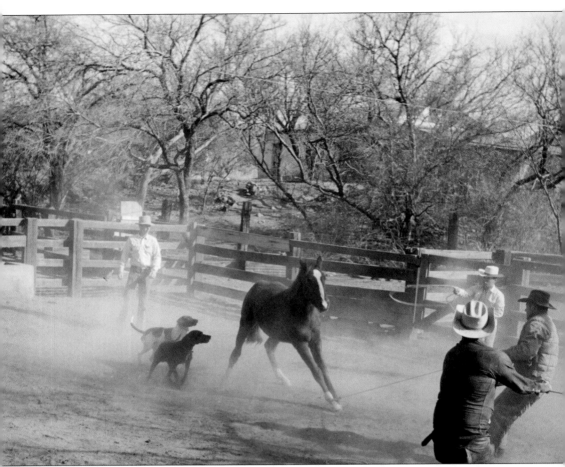

HORSE FOREMAN. The primary job of the Circle Z horse foreman is to match each guest to comfortable saddle and the right horse. Usually this involves having the guest take a ride or tw under the watchful eye of the foreman. By the end of the week, a good match is made to th satisfaction of the rider. The next year, the returning guest knows to ask the foreman to rid this same horse. The remuda of 70 horses was kept at night in the large arena by the rodeo field Ensuring the brood mares were bred to produce colts was the responsibility of the foreman an cowboy-wranglers. This is how the herd was kept fresh. Guests would be able to ride the broo mares only up to a certain time. Shown in this Ray Manley photograph is a colt being lassoed From left to right are John Kuhn, unidentified cowboy, Cano Quiroga, and Gilbert Quirog (Courtesy of Gilbert Quiroga.)

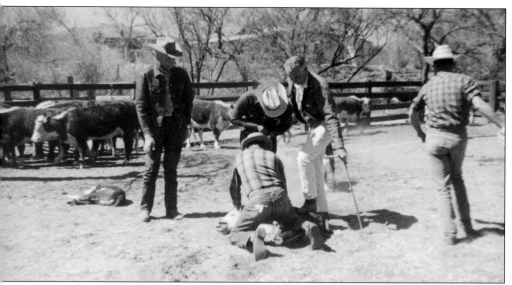

CALF BRANDING AND DEHORNING. The Circle Z had 77 head of cattle. Doug Robinson, who purchased the ranch from the Zinsmeisters, used to run Brahma herds on the property. During the 1950s, the stock was 95 percent American Herefords. By the 1970s, Fendig was crossing Herefords with a Charolais bull, a French breed that was tick resistant. The crossbreed thrived in the semi-desert grassland habitat. Hereford cattle were brought in from the neighboring Hard Luck Ranch, owned by the Bergier family. The livestock was always branded, dehorned, and castrated in the corral. Above, Fred Fendig (center, right) helps the team brand calves. Shown below is a calf being dehorned in the corral. From left to right are Ralph Padilla, Bob Quiroga, John Kuhn, and Gilbert Quiroga. These photographs were taken by Ray Manley. (Both, courtesy of Gilbert Quiroga.)

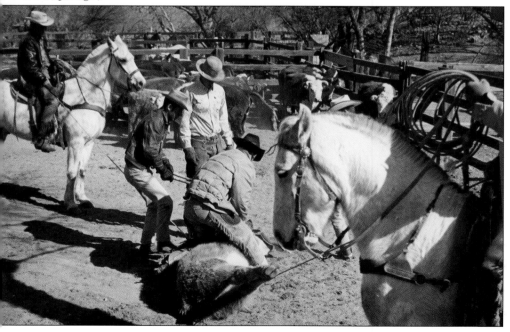

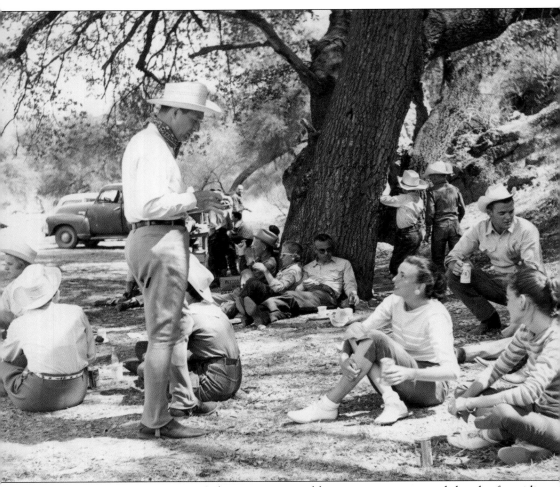

FLUX CANYON TRAIL RIDE. The guests pictured here are enjoying a pack lunch after riding t
the Flux Civilian Conservation Corps campsite in the Patagonia Mountains about three mile
south of Patagonia, not far from the ranch. The camp was designated Camp F-63-A Flux Canyor
Company 2847 occupied the camp from November 1933 through December 1935. In 1934, th
enrollees constructed wooden barracks and other camp buildings there. Bill Crawford (standing
and Fred Fendig (center) are shown in this 1956 photograph of the trail riding party at Flu
Canyon. (Courtesy of the Nash family.)

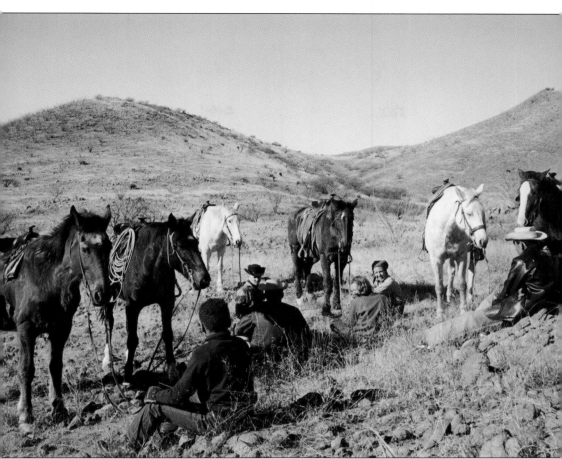

MOUNTAIN TRAIL RIDE. Wranglers took guests on all-day trail rides to the mountains with pack lunch and cowboy coffee. Many guests had never tried cowboy coffee before. In the 1960s, the Wagon Wheel Saloon did not serve food. On the short rides into Patagonia, the wranglers made sure to bring pack lunches for the guests to have with a cold beer. The guests dressed in new Western attire and mingled with the locals as if old friends. They knew the people who just rode into town were the "raw dudes" from Circle Z. The children of Orsla Semus are shown here on a mountain trail ride with wranglers Fred Moreno (center) and Ralph Padilla (far right). This photograph was taken by Ray Manley. (Courtesy of Gilbert Quiroga.)

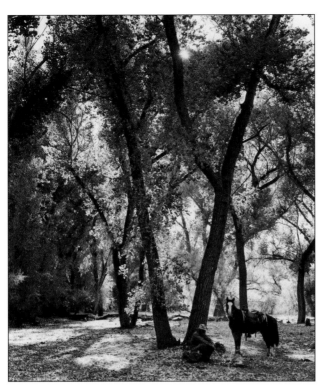

ARIZONA HIGHWAYS COVER. This photograph, titled "Autumn Campfire," was taken by Ray Manley at Circle Z for *Arizona Highways*. The image was published as the cover of the October 1957 issue. Lucia Nash had a color version of this image produced for the back cover of the advertising brochure. (Courtesy of Ray Manley Photography.)

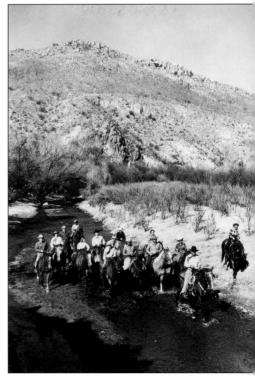

TRAIL RIDE POSTCARD. This postcard, dated March 21, 1956, was mailed by Bella, a guest at the ranch, to her friend Olga of Brookings, South Dakota. She wrote: "Here we are at the ranch 'Dudes' it is a lovely place and the people are so friendly like a big family. Have one family from Peru. 90 yesterday plenty of sun, scenery is beautiful right in the mountains. Bud rides every day is now in Box Canyon taking pictures. You and Tara would enjoy a stay here. They are filming here. We watched for two days." This photograph was taken by Ray Manley. (Courtesy of the Nash family.)

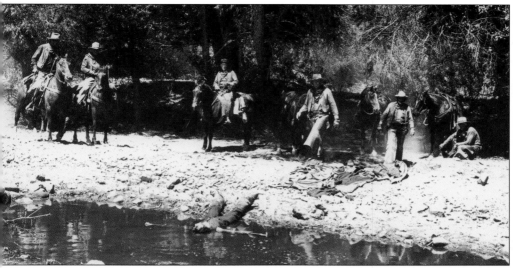

MONTE WALSH, CREEK SCENE. Actor Lee Marvin (standing second from right) walks toward the dying cowboy he shot at Sonoita Creek in June 1969 during the filming of *Monte Walsh* (1970). This movie is one of a dozen filmed on location at Circle Z Ranch, among them *Broken Arrow* (1950), *Broken Lance* (1954), *Oklahoma!* (1955), *El Dorado* (1966), *Devil's Angel* (1967), *Rio Lobo* (1970), and *Pocket Money* (1972). *Monte Walsh*, directed by William A. Fraker and starring Lee Marvin (Monte Walsh), Jeanne Moreau, and Jack Palance, takes place in Wyoming during the 1870s, near the end of the Old West. (Courtesy of the Nash family.)

MONTE WALSH, RANCH SCENE. A two-sided stage set of a ranch house was built for a scene in *Monte Walsh*. The set stood near the corrals at the far end of the polo field above Sonoita Creek. One time, an unsuspecting guest visiting Circle Z for the first time was dropped off at this shell of a house. He was told it was his bungalow for the night! This photograph of two boys cutting wood in front of the Circle Z tack room is from the "ranch scene" in the movie. (Courtesy of the Nash family.)

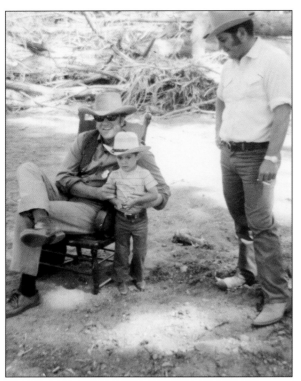

GUNSMOKE. *Gunsmoke* (1955–1975) and *Young Riders* (1989–1992) are among the popular American Western television series filmed on location at the ranch. The stories of the long-running *Gunsmoke* took place in and around Dodge City during the settlement of the American West. Actor James Arness played the central character, lawman Matt Dillon. At left, Arness (right), Michael Quiroga, and Gilbert Quiroga are on the set. Below, Michael Quiroga is saddled up on Marshal Matt Dillon's horse, Buck, to watch the filming of a scene on the 17th day of shooting *Gunsmoke V*, directed by Jerry Jameson. Arness returned to Circle Z in 1994 for the filming of the television movie *Gunsmoke: One Man's Justice*. The ranch property was used as a location for *Mutual of Omaha's Wild Kingdom*, a popular wildlife documentary television series hosted by Marlin Perkins (1963–1985). (Both, courtesy of Gilbert Quiroga.)

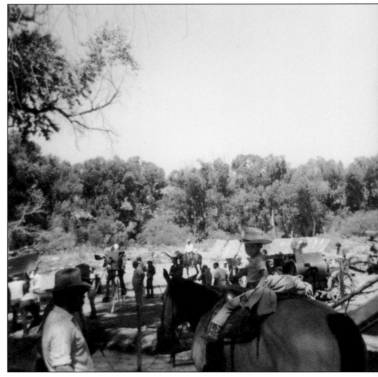

SCENIC VIEWS. By 1971, Circle Z had a string of 70 horses and a herd of beef cattle that kept Fred Fendig busy the entire year. Fendig had 18 employees at the peak of the November-to-May season. Four cowboys stayed on to help him with the cattle and horses during the off-season. The Circle Z was one of 40 members in the Dude Ranchers' Association. The dude ranch industry in the United States was in a decline. Dude ranch owners were selling their businesses. Fendig attributed this trend to the low monthly earnings of working cowboys and the poor cattle market. When interviewed by a reporter from the *St. Louis Post Dispatch*, he said, "This plays right into the hands of real-estate speculators." The image at right shows a Circle Z wrangler enjoying a moment of solitude at Sonoita Creek. Below, a Circle Z trail ride party is seen through the jagged rock formations in the hills of the rough terrain. (Right, courtesy of Ray Manley Photography; below, courtesy of the Nash family.)

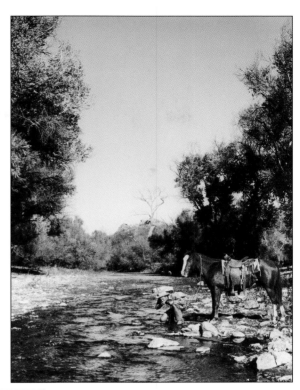

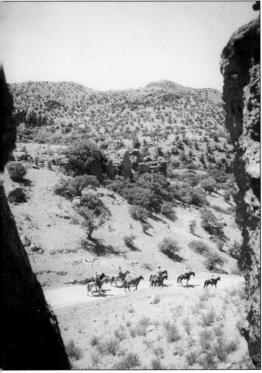

FRED FENDIG OF CIRCLE Z. In 1974, Patagonia Lake became a state park and Fred Fendig officially retired from operating the Circle Z Guest Ranch and raising livestock after 25 years of ownership. He decided to put Circle Z up for sale. The property comprised 2,000 acres of unspoiled land. Circle Z headquarters included 12 ranch buildings and seven guest cottages. After Circle Z was sold, he planned to do some traveling, move to Tucson, and buy a Jaguar luxury car. He did just that. Frederick Fendig died in Tucson on January 5, 2001, at the age of 90. In the 1952 photograph at left, Fendig poses in front of the main lodge. The photograph below was taken the first time Fendig came back to visit the ranch after he moved to Tucson. (Left, courtesy of the Nash family; below, courtesy of Gilbert Quiroga.)

Five

PRESERVING THE BEST OF THE PAST FOR THE FUTURE

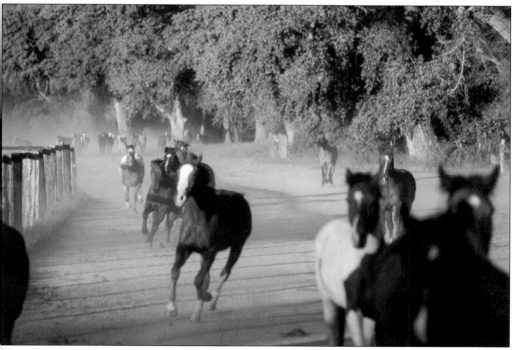

CIRCLE Z REMUDA. In the tradition of the early days of El Sultan, Circle Z's string of quarter horses remains the pride of the ranch. They are well known for being gentle and well trained. Many are sired, raised, and trained at the ranch. Today the remuda is more than 100 horses strong. (Courtesy of StevensonPhotography.com.)

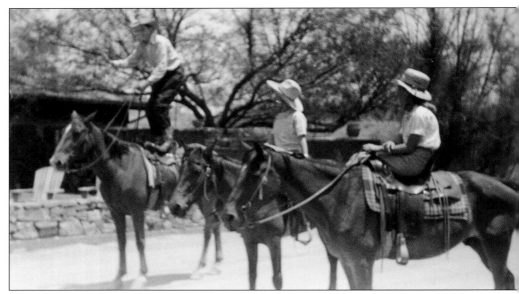

LUCIA SMITH. Kelvin and Eleanor Smith of Ohio and their daughters Cara and Lucia were longtime visitors of Circle Z Ranch during the Zinsmeister era. Helen Zinsmeister remembered the Smith family as being "delightful guests." Lucia was about 11 years old when she and her family spent their first vacation at the ranch in March 1936. According to the ranch guest register, the family returned each year through March 1943. In the c. 1930s photograph above, Lucia (center) and Cara (right) watch their friend Paul Weaver (left) showing off his trick-riding skills. Lucia Smith married Preston Nash Jr. and they made their home in Novelty, Ohio. They were guests at the ranch with their children, Audrey and Rick, since 1969. The 1961 photograph of Lucia and Preston below was taken on a vacation in Cuernavaca, Mexico. (Both, courtesy of the Nash family.)

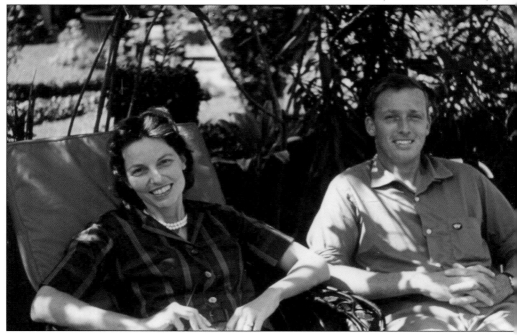

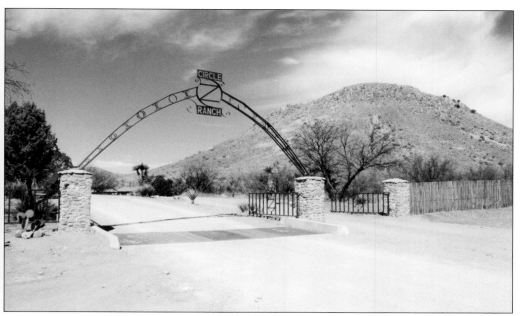

RANCH HEADQUARTERS. In 1969, the Nash family met Don and Doris Simmons Jr. of Sewickley, Pennsylvania, and their two children at Circle Z during the Christmas holiday. From then on, the two families spent every spring vacation together at the ranch. Soon after Fred Fendig announced his retirement in 1974, rumors began to circulate that the guest ranch was to be acquired by a land development corporation or become a tennis ranch. Preston Nash stated, "Our deep interest and enjoyment of the area, stemming originally from Lucia's many visits to the ranch as a child with her family, added to our concern for what would happen to Circle Z. These considerations ultimately led to our decision to become the new owners. These photographs of the Circle Z entrance and main lodge were taken in the 1970s. (Both, courtesy of the Nash family.)

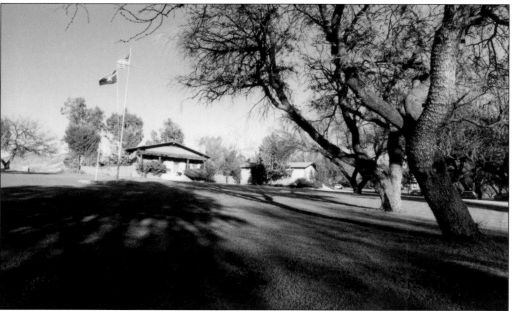

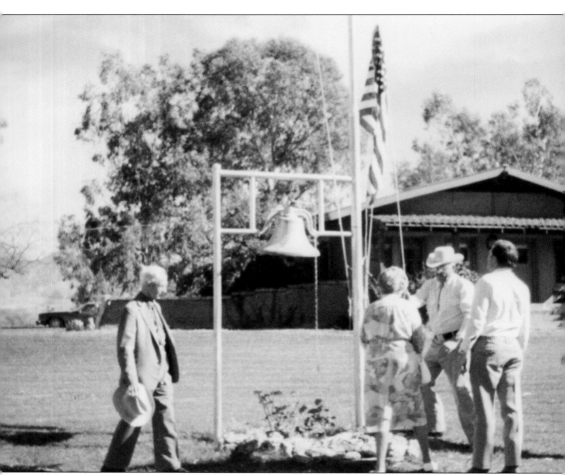

GRAND OPENING DAY. In December 1975, Preston and Lucia Nash and Kelvin and Eleanor Smith purchased all the interest from Fred Fendig for an undisclosed amount. Lucia Nash called Don and Doris Simmons and said, "We bought it. You come and run it!" They accepted the offer and purchased a small interest in Circle Z. Don, an engineer, and Doris, a nurse, left their jobs to be the resident general managers from October to May. The ranch was fully booked for the start of its 49th season. Preston and Lucia Nash continued to live in Ohio to maintain their industrial equipment sales business and raise Thoroughbreds. Pictured at the grand opening of Circle Z are, from left to right, Kelvin Smith, Don Simmons, Helen Nash (Nash's mother), Preston Nash Jr., and Lucia Nash. (Courtesy of the Nash family.)

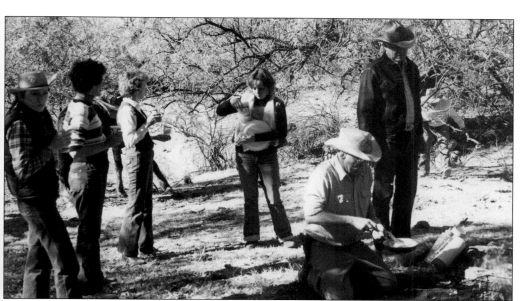

DON AND DORIS SIMMONS. Don Simmons Jr. was a teenager at Greenfields School in Tucson when he first visited the guest ranch with the private school over winter break in 1936. He was an experienced rider. Simmons had fond memories of going with Lee Zinsmeister on hunting trips with the hounds and of El Sultan and Zinsmeister riding in the Tucson Rodeo Parade. His love of Circle Z and his childhood recollections prompted him in 1962 to call Circle Z to see if it still existed. Don and Doris Simmons stayed there with their two children over the Christmas holiday. The family fell in love with this special place, the wide-open spaces, and the way of ranch life. Lucia Nash said, "Don and Doris are most enthusiastic about making guests feel welcome and well-cared for." The Simmonses treated everyone who visited or worked at Circle Z like family. The couple and their son and daughter worked side by side with the staff. In the 1978 photograph above, Don Simmons prepares breakfast for guests on a cowboy cookout trail ride. In the words of Doris Simmons, "Circle Z was part of our life. Once you've been there, you never forget it!" Below, Doris Simmons poses for the camera. (Both, courtesy of the Nash family.)

THE MAIN LODGE AND CANTINA. Plans were undertaken in 1974 to rebuild the tennis court, make improvements to the swimming pool, repaint the buildings, and redecorate. Lucia Nash ensured the elegance of the dining experience for her guests in the manner Lee and Helen Zinsmeister established. The 1975–1976 guest booklet stated politely, "Though we pride ourselves on being an informal family ranch, we ask that no riding clothes be worn at dinner. Gentlemen are requested to wear a tie, bolo tie, or turtleneck for dinner, and for the ladies, dresses, slacks or skirts. Children dine in a separate room at an earlier hour and need not dress up." Great food, horseback riding, relaxation, and Western hospitality continued to be what guests enjoyed and came to expect. The main lodge and cantina are pictured in these 1980s photographs. (Both, courtesy of StevensonPhotography.com.)

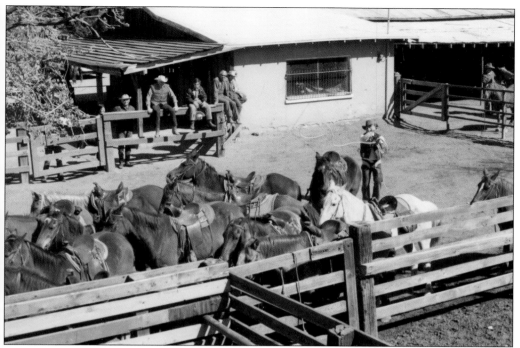

LOS CORRALES. Most guests would sit on the fence to watch wranglers round up the saddle horses, brand calves, and break horses in Los Corrales (the corrals). Below, George Lorta and Circle Z wranglers head out to round up horses for the early-morning trail ride. The wranglers pictured behind George Lorta, from left to right, are Jennie Lorta, Jessie Dugan, Miko Lorta, unidentified, and Chad Lorta (far right). George Lorta worked as the Circle Z corral manager for 39 years. Seen in front of the tack room below is a *retaque* fence (mid-ground, far right). This type of fencing was typically used to corral livestock in the pioneer days. Vaqueros would construct the enclosures by stacking up mesquite between two posts. (Both, courtesy of Ray Manley Photography.)

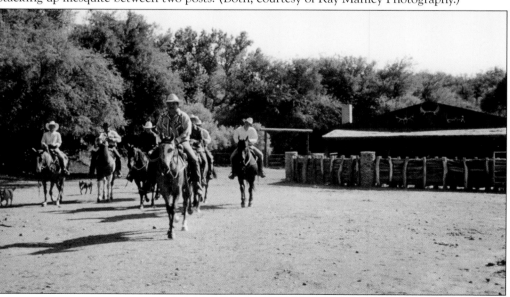

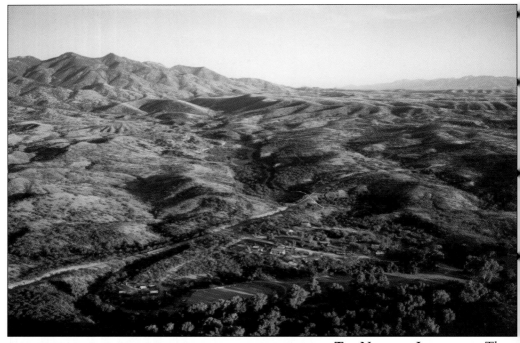

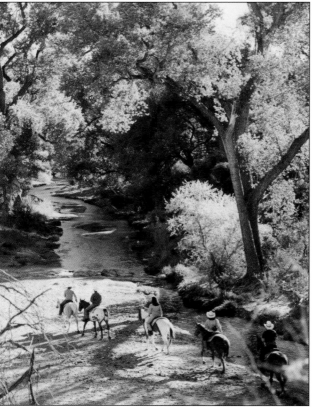

THE NATURAL LANDSCAPE. The biodiversity of the area evokes a sense of peace and solitude that is one of the many attractions that lure guests to the ranch. The Nature Conservancy's Patagonia–Sonoita Creek Preserve and Patagonia Lake State Park were built near the Circle Z. The Sonoita flood plain is known as an important migratory bird area. Guests enjoy the variation of the landscape, as seen in the panoramic view above, taken in 1991 from Circle Z Mountain. Sonoita Creek (left) is one of the rarest riparian zones in Arizona. It provides habitats for a diverse array of rare and endangered species such as the Fremont cottonwood and Goodling willow. Some of the cottonwoods are more than 100 feet tall and 130 years old. The northern harrier, ruby-crowned kinglet, green-tailed towhee, and Lincoln's sparrow have been spotted during winter. (Both, courtesy of StevensonPhotography.com)

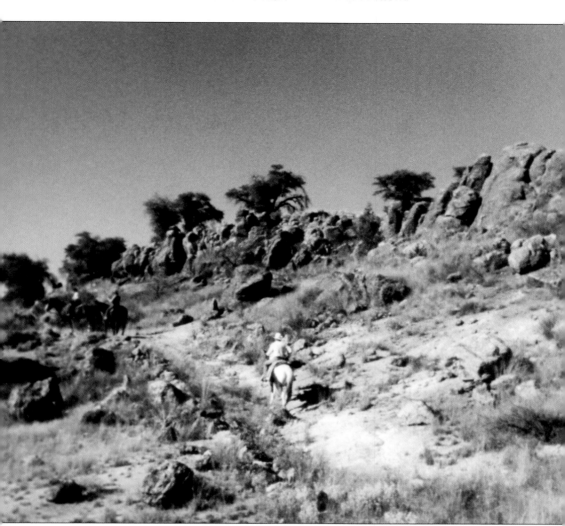

Spencer Tracy Trail. The wranglers guide trail parties from the corral to Sonoita Creek through the cottonwood-willow habitat to the high desert grasslands in a matter of minutes. Horseback riding on the endless trails on varied terrain is the outstanding pleasure for guests at the Circle Z. Wranglers employed by Fred Fendig sometimes paused on the "Spencer Tracy Trail" on the ranch property. They'd point at a hole in the ground and say, "That's Spencer Tracy's grave. It was in a movie." Actors Spencer Tracey and Robert Wagner starred in the 1950s movie *Broken Lance.* The trail party in this 1970s photograph rides the Spencer Tracy Trail where the burial scene from *Broken Lance* was filmed. (Courtesy of StevensonPhotography.com.)

WESTERN SADDLE HORSES. Circle Z horses have been the centerpiece of the guests' experience for the past 90 years. The remuda has a large day corral plus a night pasture where they roam during the six-month guest season. During the summer, when the ranch is closed, the horses are allowed to run free on the property. In the honored tradition, guests gather on the porch of the tack room soon after arrival to be assigned a horse chosen by the corral manager. There's a suitable horse

and a comfortable saddle to match each rider's level of experience. Each guest receives a short course on safety and horseback riding rules before heading out on rides. The ranch offers five to six hours of riding each day, and guests can opt for shorter experiences. Children ride in their own separate group. Adults ride in smaller groups. The afternoon ride is optional. Individualized horse lessons for guests are available upon request. (Courtesy of StevensonPhotography.com.)

LUCIA NASH AND ELEANOR SMITH.
Industrialist and philanthropist Kelvi
Smith, Lucia's father, was a chemical
engineer and cofounder of Lubrizol
Corporation. The corporation becam
the world's leading manufacturer of
lubricant additives for oil. Lucia Nash
shared her father's love of horses,
passion for nature, and concern for
land conservation. Lucia Nash is
posed on her mount, Pablo, at left
in 1980. Smith developed a wide
range of riding trails on land he
owned in Geauga County, Ohio.
He was a substantial contributor
to numerous nonprofits in Ohio,
supporting music, education, and
marine biology research. He died in
1984 at the age of 85. The Nature
Conservancy's Tucson office dedicate
a nature trail in Smith's memory in
appreciation of his years of support of
the organization in Patagonia. Lucia
Nash (left) and Eleanor Smith (right)
are pictured below in the main lodge
with the trailhead sign on display.
(Both, courtesy of the Nash family.)

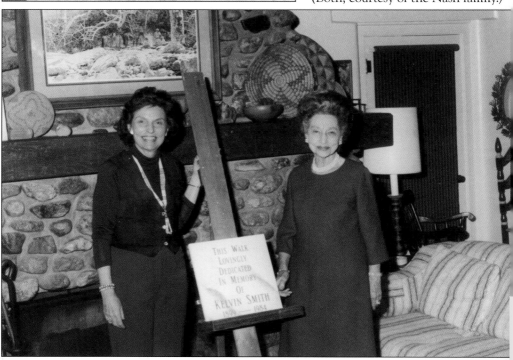

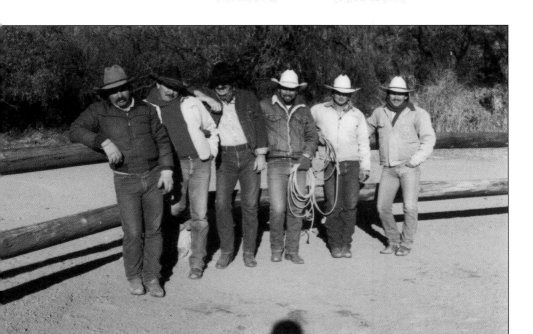

CIRCLE Z WRANGLERS. Experienced and personable wranglers are still considered the heroes of Circle Z. They offer guests customized rides and all-day trail rides and sometimes demonstrate horsemanship skills. Sundays are considered a "horse holiday." The day is reserved for scheduled hikes, picnics, sightseeing, or just relaxing. Posing in the corral in the 1980s photograph above are the wranglers charged with the trail rides, equine care, and cleaning the corrals. From left to right are Tony Siggins, George Lorta, guest Roberto Mambria, Richard Ronquillo, William Lorta, and Art Lorta. Below, wrangler Danny Skiver shows off his skills on a chuck wagon trail ride at the Lion's Den picnic area along Sonoita Creek. (Both, courtesy of the Nash family.)

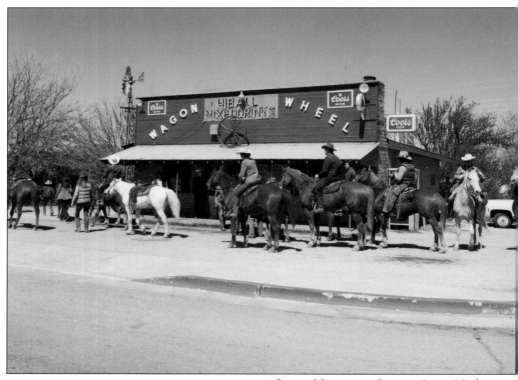

LUCIA NASH AND GUESTS. Lucia Nash is an accomplished equestrian. When she goes on a trail ride with guests, she is always a perfectly dressed cowgirl. In the 1970s photograph above, Lucia Nash (center) and Circle Z guests arrive at the Wagon Wheel Saloon. She frequently rode with guests on all-day trail rides. She wrote in a notebook about her trail ride experience and suggestions to improve the day trip for guests. On a six-hour, all-day ride at Gardner Canyon and Mount Wrightson in the Santa Rita Mountains, she wrote: "Ride only strong horses. We might have gotten up 20 minutes sooner except for giving Valentine extra rests. Take only experienced riders who are thoroughly comfortable in their saddles. It's a long downhill trek." The 1980s photograph at left shows Lucia Nash on her favorite mount, Julie. (Both, courtesy of the Nash family.)

JERRY AND NANCY HOLMES. Betsy and Bryan Laselle became the resident general managers after Don and Doris Simmons retired. Longtime guests Jerry and Nancy Holmes pose on horseback at Sonoita Creek. They were the resident general managers for Lucia Nash in the 1990s. The couple had strong business backgrounds. Each was an accomplished equestrian. Jerry Holmes prided himself as the one who taught Elvis Presley to ride. Holmes kept a framed photo of himself and Elvis in the office of the main lodge. (Courtesy of the Nash family.)

CIRCLE Z SURREY. Holmes is credited with refurbishing the surrey Lee Zinsmeister entered in the Tucson Rodeo Parades of the 1930s. The antique had been disassembled and packed away in the garage. This photograph taken in 2000 shows Jerry Holmes driving a guest in the surrey across the Sonoita Creek. The surrey is used for Circle Z special events. (Courtesy of the Nash family.)

THE LORTA FAMILY. George and Jennie Lorta are the current resident general managers. George Lorta, of Lochiel, Arizona, has lived and worked on the Circle Z since he was 17 years old. Dor and Doris Simmons hired him as a wrangler and all-around ranch hand. Circle Z continues as a winter guest ranch and cow-calf operation. Currently, 60 head of Beef Master cattle are run on Circle Z rangeland. George Lorta has worked for the Nash family since 1975. In his words, "There's no place I'd rather be." Jennie Lorta met George at a Sonoita Rodeo team roping competition. They later married and raised sons Chad and Miko on the ranch. Jennie Lorta hired on as a wrangler in the 1980s. The Lortas' oldest son, Chad, worked as a wrangler in the mid-1990s. In 2014, wrangler Miko Lorta became the corral manager. Jennie Lorta commented, "We are one big family here. This is what we experience and want to give to the guests." Pictured in 2007 are, from left to right, George Lorta, wrangler Randy Code, Jennie Lorta, Miko Lorta, and wrangler Stephanie Shaw. (Courtesy of the Nash family.)

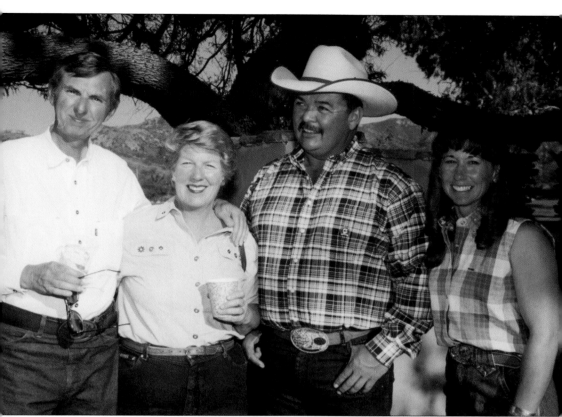

RESIDENT GENERAL MANAGERS. The Nash family has employed five resident general manager couples over the past 41 years. Each manager developed a family relationship with guests. Jim and Ginny Cosby were the ranch managers from 2003 to 2008. In this 2001 photograph at the 25th anniversary party are, from left to right, Jim Cosby, Ginny Cosby, George Lorta, and Jennie Lorta. (Courtesy of the Nash family.)

DIANA, LUCIA, AND RICK NASH. Rick Nash, Lucia's son, and his wife, Diana, are members of the Nash family management team. Rick and Diana's passion for the Circle Z Ranch comes from the powerful memories of times spent at the ranch as a family. The ranch is continuing the way guests remember it. The Nash family is dedicated, as Lucia said, "to preserving the best from the past while adding a bit to your future pleasure." Diana and Rick Nash pose with Lucia Nash in 1995, shortly after they were married. (Courtesy of the Nash family.)

25THANNIVERSARY PARTY. Shown here are Lucia Nash, Diana Nash, and Rick Nash at the 25th anniversary party to celebrate the Nash family's 25 years of ownership and 75th season. The year 2016 marks the 90th anniversary of the Circle Z Ranch as the oldest continuously operating guest ranch in Arizona. (Courtesy of the Nash family.)

PRESTON NASH. Lucia's passion for horses was influenced by her many visits to Circle Z in her youth. Preston Nash and his parents, Rick and Diana, visited the ranch during the winter seasons. Lucia delighted in taking her only grandchild for walks around the property. Chiquita is the Shetland pony seen in the photograph above, taken when Preston was two years old. When interviewed by Tom Seay, host of the *Best of America by Horseback* television show, Rick Nash said: "What I like most about the ranch is that my son will be able to carry the Circle Z experience with him. He [Preston] likes to go riding—it gives him a sense of space and appreciation for this open country that we call Circle Z." Miko Lorta (left) and Preston Nash (right) pose for the camera in the 2007 photograph at right. (Both, courtesy of the Nash family.)

LUCIA SMITH NASH. Lucia's love of horses and her father's influence led her to become an accomplished equestrian, successful businesswoman, and ardent conservationist. Her aim was to operate a warm guest ranch in an atmosphere of Old West simplicity and in keeping with the Zinsmeister tradition. Over the decades, she became a steward of the land. She purchased rangeland and nearby ranches out of a responsibility to protect Sonoita Creek for future generations. By 2015, the Nash property included 6,500 acres of deeded land, protecting over two miles of Sonoita Creek. She is passionate about preserving the timelessness of the Circle Z experience for her guests. In February 2016, Lucia Nash was inducted into the Dude Ranchers' Association Hall of Fame. She was recognized for her many contributions to the association and the dude ranch industry. In the words of the association, "Because of pioneers like Lucia, the warm, Western hospitality you find at dude ranches is well established and still going strong." Above, Lucia smiles proudly with a new foal. The portrait of Lucia Smith Nash at left was taken in 1996. (Above, courtesy of the Nash family; left, courtesy of StevensonPhotography.com.)

BIBLIOGRAPHY

Barr, Betty. *Hidden Treasures of Santa Cruz County*. Sonoita, AZ: Betty Barr, 2006.

————. *More Hidden Treasures of Santa Cruz County*. Sonoita, AZ: Betty Barr, 2008.

Cady, John Cady, and Basil D. Woon. *Arizona's Yesterday: Being the Narrative of John H. Cady, Pioneer*. Tucson, AZ: Adobe Corral/Westerners International, 1915.

"Circle Z Ranch, Patagonia, Arizona." *Best of America by Horseback*. Culpeper, VA: RFD-TV, February 24–March 1, 2015.

Don Alonzo Sanford Papers Collection (MS451), Box 52, Folder 8.

Egloff, Fred R. "Circle Z Ranch and the Sonoita Valley." *The Westerners Brand Book* 9 (January-February 1978).

Kupel, Douglas E. "Patagonia: The Jewel of the Sonoita Valley." *The Journal of Arizona History* (Spring 1995): 55-82.

The Patagonia Museum Oral Histories 2009–2012. Oral histories of Lydia De La Ossa Dojaquez and Jeanette Swyers. Patagonia, AZ: The Patagonia Museum, 2012.

Ryden, Don W. *A Historic Resource Survey of the Town of Patagonia, Arizona*. Phoenix, AZ: AIA/ Architects Inc., 1994.

Sheridan, Thomas E. *Landscapes of Fraud: Mission Tumácacori, the Baca Float, and the Betrayal of the O'dham*. Tucson, AZ: The University of Arizona Press, 2006.

————. *Arizona: A History*. Tucson, AZ: The University of Arizona Press, 2012.

Zinsmeister, Lee G. "Old Sanford Ranch." *Westward Ho Magazine* vol. 1 (November–December 1929): 16 and 45.

DISCOVER THOUSANDS OF LOCAL HISTORY BOOKS
FEATURING MILLIONS OF VINTAGE IMAGES

Arcadia Publishing, the leading local history publisher in the United States, is committed to making history accessible and meaningful through publishing books that celebrate and preserve the heritage of America's people and places.

Find more books like this at
www.arcadiapublishing.com

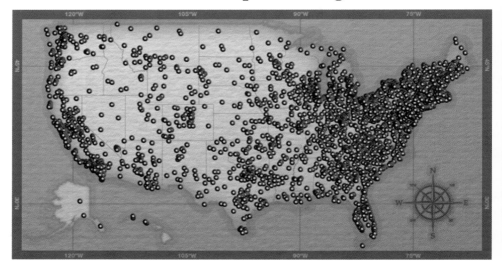

Search for your hometown history, your old stomping grounds, and even your favorite sports team.